SEE/SAW

古⇄今

SEE / SAW

CONNECTIONS BETWEEN JAPANESE ART THEN AND NOW

By IVAN VARTANIAN and KYOKO WADA

With features on TABAIMO, MAKOTO AIDA,
TAKASHI MURAKAMI, YOSHITOMO NARA, TADANORI YOKOO,
ISAMU NOGUCHI, and YAYOI KUSAMA

CHRONICLE BOOKS
SAN FRANCISCO

TABLE OF CONTENTS

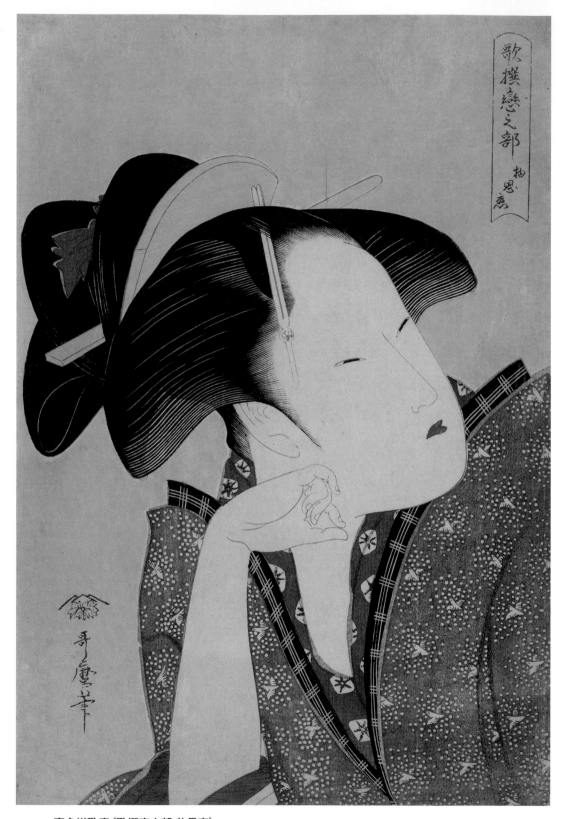

喜多川歌麿《歌撰恋之部 物思恋》

Fig. 1: Utamaro Kitagawa, Mono-omoi-koi (Lost in Thoughts of Love), 1793–94 (Edo period). 39 × 26.1 cm. Woodblock print.
Photograph © 2010 Museum of Fine Arts, Boston.

Introduction

Hey There,
Welcome to a Small World

This book is a compact catalogue of Japanese art, pairing contemporary pieces with works that are in some cases several hundred years older. Having seen so many instances where contemporary Japanese artists make reference to traditional Japanese art, we have found a (sometimes covert) trend that cuts across all genres and disciplines: the new is old, or the old is new.

There is a current penchant in Western discourse to see the contemporary art of any culture as a process of self-reference or, at the most, reference to current cultural markers. On the other hand, much contemporary art and literature in the West can seem to make no apparent reference whatsoever—as if the work was created *ex nihilo*. This anxiety in the West stands in contrast to a comfort with—if not eagerness for—influence in the East.

As well as objects that are designated as national treasures and artworks that are widely celebrated or highly appraised in auction houses, the pieces featured here include materials that may not necessarily fit the traditional definition of art—craft items, architecture, gardens, large stones found in nature, massive trees, product design, magazines, 18-wheelers, or—staples of Japanese subculture—anime and manga. The book spans a broad time period, from examples of the world's oldest earthenware, circa 3000 BCE, to some of the most recently exhibited pieces of contemporary art—a breadth of about 5,000 years.

Such variety from such a small country may seem remarkable, but not in the case of Japan, which functions as a sort of repository of ideas both domestic and foreign, new and old. Art critic and philosopher Tenshin Okakura, who once described Japan as the storehouse of Asian culture, put it thus: "One after another the waves of Asian thought have crashed against our nation's consciousness, leaving traces in the sands of our beach." In 1977, when French anthropologist

Claude Levi-Strauss first came to Japan to conduct field research, he had a similar insight: "Japan is highly homogenous ethnically, linguistically, and culturally. However, the elements that are added to it are tremendous. Japan is a place of encountering and mixing. Positioned furthest east, the island nation experienced multiple periods of isolation, which served as a sort of filter. Put another way, Japan absorbed those small, precious kernels of culture and history that were distilled from foreign lands. Borrowing and unification, mixing and creating. The repetition of that activity has established the role and unique status of Japanese culture within our world" (from an NHK interview excerpted in Takaki Ookubo's, *Midasareta Nihon*, Heibonsha Sensho, 2001).

To illustrate his point, Levi-Strauss used the two oldest surviving books in Japan: *Kojiki* (*The Record of Ancient Matters*) and *Nihon Shoki* (*The Chronicles of Japan*). They cover all aspects of the world's primitive ancient mythology, though in other parts of the world such records are only fragmentary. In this way, Japan can be seen as the end of the world, as a storehouse of all mythology that forms the origins of human thought. In its absorption of ideas from other cultures, it also becomes a repository. Japan, as the world's future, is simultaneously the world's past. It is a model of a small world getting even smaller.

Until recently, Japanese creators in all fields shied away from being tied to a Japanese identity, preferring instead to be recognized and understood on a more international frame of reference. This was likely an extension of the hegemony of Western art exerting its standards on the modes and content of expression. At the same time, it expressed the need for validation by a big brother of sorts—a dynamic that is certainly not specific to Japanese art alone and can be seen in many fields of contemporary art. What we see emerging now in Japan is a greater comfort among artists to create work that doesn't make itself readily accessible to a Western audience. Where artists were once

日本美術史の輪郭線

曾我蕭白《達磨図》
Fig. 2: Shōhaku Soga, *Bodhidharma*, c. 1765. Hanging scroll; ink on paper. 92.3 × 121.7 cm. Private Collection.
Photograph by Kyoto National Museum.

concerned by some things getting lost in translation, now we see a growing trend amongst artists to create work that may speak to a limited audience or even work that outsiders—of whatever level—would need to make an effort to parse or appreciate. A lot of the contemporary art included in this volume would fall into that camp and, oddly enough, in comparison, many of the older artworks are easier to access.

The Aesthetics of Combination

Our pairings of artworks may be jarring at first. The use of computers to render animation or vector graphics seems wholly devoid of any connection with the hand labor of paneled screens and scrolls. The reverb of pop references and garish colors clash with the solemnity of monochromatic brush strokes in one place, or the golden hue and moss-colored palette of a thirteenth-century building seems to be at odds with the steel and glass of a contemporary structure. But the impulse to look for and draw out the parallels between what's past and what's new is a phenomenon of this particular time—our largely digital age. The Internet has brought about a synchronization of cultures internationally, to such a point that everyone seems to be doing the same thing at the same time; or at least is aware of what is happening globally at the same time. This globalization of thought is the means by which contemporary art, photography, design, architecture, fashion, literature, and more is understood. At the same time, there seems to be a growing trend of appreciating the Japanese sense of the local and domestic intrinsic culture, even in foreign countries.

We wanted to look once again at the roots of Japanese art, and through this etch out in some way what it means to be Japanese today. In other words, what is the Japanese identity in a contemporary context that is post-globalism,

post-pop, post-digital takeover? The idea of synchronizing the anachronistic is something that has been happening in Japanese art for quite some time. It wouldn't be an exaggeration to say that it is almost a practice *de rigueur* for Japanese artists to recast traditional themes or compositions in contemporary terms.

Take, for example, the conglomerate nature of Buddhism in Japan. When Buddhism was introduced to Japan in the sixth century, it did not happen at the expense of faiths that were active—rather, the imported religion was mixed in with pre-existing faiths. (We explore this in greater detail in chapter 6, Animism.) Another example is the Japanese language itself, which is an identifiable mixture of several different writing systems. The characters used in Japanese, kanji 漢字, are imports and adaptations from China that are written in combination with the more cursive-looking system hiragana ひらがな. Kanji is a system of pictographs and ideographs; hiragana is solely phonetic. There is also a separate writing system, katakana カタカナ, which is meant for foreign words and expressing interjections. And, finally, there is the Roman alphabet, which is frequently used in advertising. Beyond function and form, each of these systems carries a different feel, and their combination in deployment is fine-tuned to the writer's intent. A good example of this is manga, in which the words (which are not minimal in amount) are written such that the reader's pace maintains a consistent speed, interacting with the images in such a highly coordinated manner that it is no surprise that manga culture has blossomed to such an elaborate extent in Japan.

Japanese is traditionally written vertically, from the top of the page to the bottom, and from the right to the left. Thanks to foreign influence, Japanese can also be written horizontally, progressing from left to right. This means that some Japanese books start at one end and some books start at the other

日本美術史の輪郭線

end; the books are read in different directions depending on how the type has been set—vertically or horizontally. (We have used this for graphic effect in the book's typesetting.) This variety is utterly commonplace for Japanese readers; that said, it is rare to see a manga that is set horizontally.

Apart from these mechanics, there is another important facet of contemporary Japanese to touch upon—despite the indoctrinations of many foreign influences and the developments both social and economic, the Japanese language has maintained a basic consistency throughout its history. Consider, for example, the *Tale of Genji*, one of the most broadly studied texts of Japanese literature of any era. It was written circa 1000 BCE, around the time that the epic *Beowulf* was written. With a little effort, the average Japanese can read the *Tale of Genji*, whereas *Beowulf*, written in Old English, is unintelligible to most modern English speakers. This consistency of language through time demonstrates, by extension, a consistency in philosophy and thought of its culture and civilization, maintaining the existing systems while slowly accommodating the new, and mixing both in the process.

In Japanese, the verb "to learn" (学ぶ, *manabu*) originally came from the verb "to imitate" (まねぶ, *manebu*), which has the same etymology as "mimic" (真似る, *maneru*). In art, the terms *maneru* (mimic) and *utsusu* (写す, copy) were principal standards by which aesthetic expression was assessed in Japan. (Consider this as opposed to the value placed on originality in the artistic traditions of many other cultures.) When the Japanese artist Sesshū (fig. 55) learned the art of *saiboku-ga* (contrasting light and dark ink on paper) from China, he signed his work as *hitsuju*, meaning that he was translating some other work. Widely recognized as the progenitor of *sumi-e* drawing in Japan, Sesshū nevertheless credited himself as a translator of the technique he learned from Chinese artists.

The Ideology of Imported "Art"

Prior to recent years, the *idea* of art was translated to Japanese as 美術 *bijutsu*, a combination of the characters for "beauty" and "skill." This was brought about by the introduction of the Western word "art" to Japan. In a similar way, words such as 自由 (liberty), 社会 (society), and 自然 (nature) were also created in response to Western culture. "Art" became a codified genre for the first time. Simultaneous with this was the broad dividing line that was drawn between "art" and "craft" (工芸). From the mid-nineteenth century on, there was a large movement of "decorative arts," which Japanese art historian Nobuo Tsuji describes: "From the perspective of painting it looks like craft and from the perspective of craft it looks like paintings; it maintains a duality." This duality is the hallmark of Japanese aesthetics.

The influence of Western thought on Japanese art (as well as society and history) was, needless to say, considerable. The processes of categorization and the delimiting of genres brought about segmentation in how the Japanese understood their own traditions. What is cast as interdisciplinary in Western art was a fluid and pliable state of being for Japanese art, which also lent itself to a viewer/reader having a wholly different relationship with art. In the book's pairings we have made an analogy between traditional art and contemporary art, and shown how they all belong on the same axis, as opposed to being truncated by the terms "modern," "contemporary," "traditional," or "high versus low."

日本美術史の輪郭線

Toward Continually
Changing Aesthetics—Japan's Climate

Nobuo Tsuji, in comparing Japanese with Chinese art, explains, "The portrayal of nature is devoid of cool objectivity and is instead quite emotionally charged, engaging the viewer. The intense and deep stirrings that are aroused have a limitless resonance with nature" (*Nihon Bijutsu No Mikata*, Iwanami Shoten).

The role played by nature in Japanese expression is tremendous. In chapter 4, Diorama, we present how nature is represented; in chapter 5, Animism, we discuss the spirituality that has been closely linked with nature in Japan's history. Nature is ever changing, continually progressing from one state to the next with a panoply of phenomena—apart from the four seasons, there are typhoons, great waves, flooding rivers, hurricanes, volcanic eruptions, and, of course, frequent earthquakes. Despite the narrow sliver of landmass that the country occupies, it stretches long and thin from north to south, and diagonally from east to west, providing it with a rich diversity of climates and terrain—lush forests, grassy fields, and mountain ranges, which give rise to a network of natural springs (and the tradition of the Japanese bath).

In terms of time and representation of movement, contemporary animation and comics have a connection with older work. Movement in drawing can be linked to the influence of nature. Takashi Murakami said that animation-type movement is readily apparent within the still surface of Japanese paintings (figs. 6, 8, 9). Certainly water, clouds, winds, and other fluid elements are represented in Japanese painting. Jakuchū Itō (figs. 59, 103) was intentionally pursuing such themes in nature precisely for how they lent movement to a composition. In the pages of *Hokusai Manga* (fig. 81) people, or the crashing waves as depicted in *The Great Wave* (fig. 77), have a clear sense of movement. Traditional Japanese artists pursued not only the expression of elements in

nature, they also sought to render the change of seasons or the progression of time within a single composition, as in *Flowering Plants of Summer and Autumn* (fig. 49) or with the *Old Plum Tree* (fig. 22). With *Rakuchū-rakugai-zu* (fig. 4), a panorama of Kyoto progresses one season to the next from one edge of the painting to the opposite side. There is also the *emakimono* (scroll), in which the narrative—told in pictures and words—unfolds in a linear fashion, but the progression of events and their depiction is quite complicated.

Depicting change and movement in nature is tied to Japanese philosophy and religion as well. "All things are in a state of continual flux"—this is a central tenet of Buddhism, influencing not only representation and expression but all aspects of life. The *ma* of chapter 2 or the *mu* of chapter 7 are concerned not only with what is present but also with what is absent. The influence of this also pervades the baroque decorations of chapter 3 (*kabuki*) or the tongue-in-cheek playfulness of chapter 6 (*tawake*).

Reading Japanese Art:
Seven Aesthetic Points

The first chapter, *mitate*, serves as the basis for the entire book, familiarizing the reader with the idea of how elements are borrowed, adapted, or transposed to contemporary art. This, in turn, gives us a sense of how traditional Japanese art is an analogy of borrowed materials from older works or foreign works. In chapter 2, *ma*, and chapter 7, *mu*, Zen Buddhism and the idea of *wabi-sabi* are explored as a core of art-making. Where chapter 2, *ma*, deals with time and space and the importance of their balance, chapter 7, *mu*, places importance on spiritual machinations. Chapters 3, *kabuki*, and 6, *tawake*, are also closely linked. They both deal with play and how this is reflected in Japanese aesthetics. *Kabuki* in particular deals with ornament, fashion, manners, and customs,

日本美術史の輪郭線

while *tawake* deals with satire, wit, and more high-brow fun. Chapters 4 and 5 both confront nature. In 4, *kei*, human feeling is reflected in the depiction of nature, expressing the Japanese affinity for nature and its active use as an agent for expression. Chapter 5, *tama*, addresses the expression of spiritual awakening through an encounter with nature.

It is possible to migrate the works between chapters; a certain work's placement in a chapter is not meant to be a definitive reading. We have made selections based on how to best communicate the ideas we are presenting.

A Note on Names

Japanese names are written with the family first and the given name second. In this volume, all names are standardized to match a western ordering. Two exceptions to this rule are the names Tenmyouya Hisashi and Yamaguchi Akira. Both these names are ordered as they would be written in Japanese, with the family name first and the given name last. This was done with the insistence of the artists. However, when discussing pre-modern artists, such as Jakuchū Itō or Sansetsu Kanō, we make reference to the artists first name only in several places in the text. Such artists, particularly those who belonged to schools, such as the Kanō-ha (the Kanō school), were distinguished by the first name; this also gives us a sense of how artists were considered more as artisans working within a particular tradition and trained through an apprenticeship. There are also numerous instances among the early artworks that have no attribution. This is in part the inability to establish who the particular artist was of an older work, but it also reflects the anonymity of older specimens.

To preserve an accurate phonetic rendering of Japanese names and words in English, long vowels (most commonly "o" and "u") are distinguished by a macron. The long, second vowel of Tenmyouya Hisashi's family is an exception.

Also, Shinro Ohtake is an exception to this rule. He has exhibited extensively outside of Japan using the spelling Ohtake, which would be written Ōtake according to the convention of this book. The tea master Sen no Rikyū has been written about in numerous work of art history and this way of writing the name has been adopted in this volume as well. Otherwise, his name would have been written Rikyū Sen (first name followed by last name; the introduction of the "no" comes from spoken Japanese, denoting a possessive, as in "Rikyū of Sen").

日本美術史の輪郭線

見立

ALLUSION

(*mitate*)

Contemporary Art is the Future's Classic Art

A common practice of *ukiyo-e* woodblock printing was to make analogies to (or parodies of) classical paintings and literature to illustrate contemporary events, figures, and other worldly phenomena. This is known as *mitate*. Examples of such allusion occurred in various realms of creative expression—theater, literature, song, and poetry. The ability to make such a sophisticated reading, however, was possessed only by an elite set of intelligentsia. *Mitate* became quite popular in the Kamakura period (1185–1333) with *waka* (traditional Japanese poems) or *renga* (linked poems), in which poets intentionally appropriated verses, themes, or concepts of an earlier poem. A modern-day equivalent would be the hip-hop art of sampling, in which practitioners incorporate various elements of other songs into their own compositions. This chapter presents examples where title, composition, color palette, or even entire figures are lifted from one work and incorporated into another. In the process, the new work is enriched by layers of cultural and historical duality.

A Hybrid City with No Center

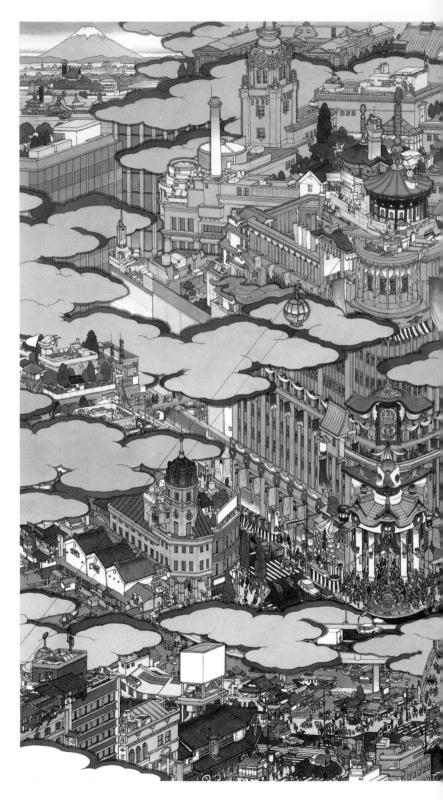

山口晃
《百貨店圖 日本橋 新三越本店》

Fig. 3: Yamaguchi Akira, *Department Store: New Nihonbashi Mitsukoshi*, 2004. Pen and water-color on paper. 59.4 × 84.1 cm. © Yamaguchi Akira. Courtesy of Mizuma Art Gallery, Tokyo.

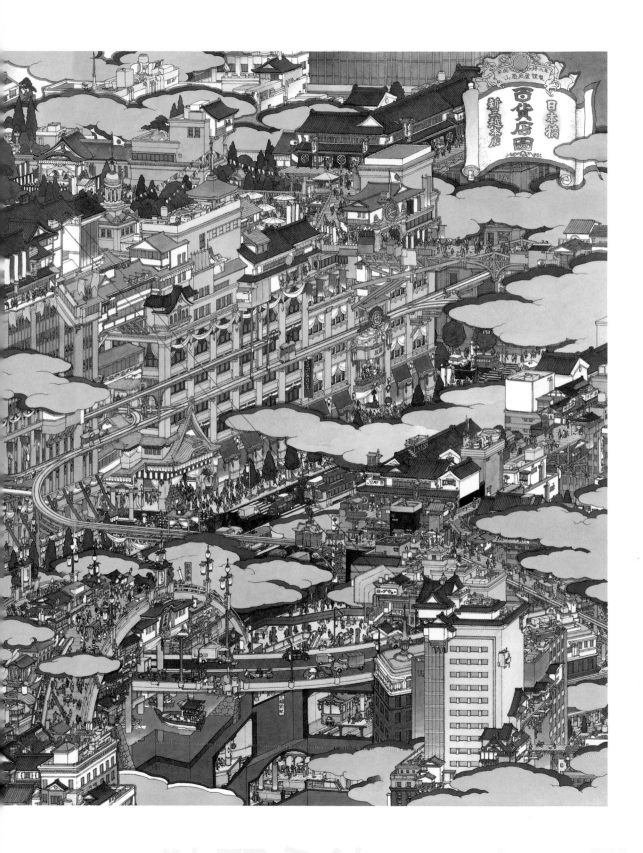

狩野永徳《上杉本 洛中洛外図屏風》（国宝）

Fig. 4: Eitoku Kanō, *Rakuchū-rakugai-zu*, late 16th century (Azuchi-Momoyama period). Gold-leaf on paper.
160.5 × 364.5 cm. Designated National Treasure. In the collection of the Yonezawa City Uesugi Museum.

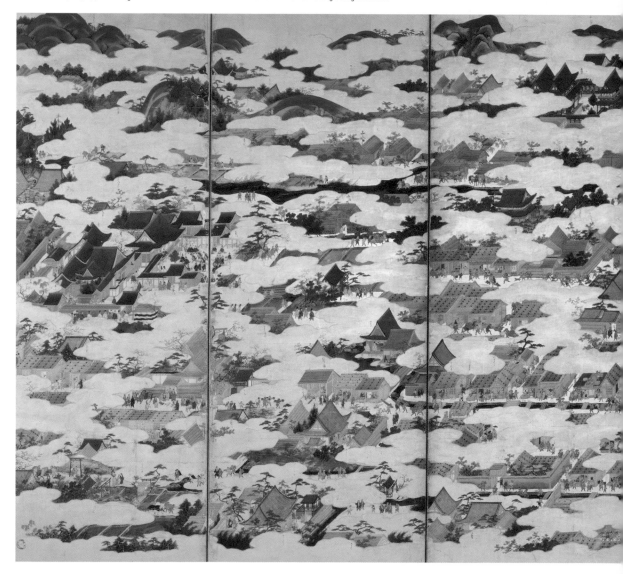

Since 1985, approximately one-third of Tokyo's buildings have been demolished and rebuilt. Even as one of the world's most industrially advanced nations, this is an unprecedented metabolic rate. The contemporary artist Yamaguchi Akira depicts just such a Tokyo (fig. 3), using a traditional Japanese landscape of *kumokasumi* (clouds and mist) and *fukinuke-yatai* (in which building roofs are omitted, to allow the viewer to see inside the structures), similar in perspective to the diagonal, bird's-eye view of Eitoku Kanō's *Rakuchū-rakugai-zu* (fig. 4). In addition to these techniques, Yamaguchi outlines shapes with a black line in the style of *sumigaki* (painting with China ink).

With the bird's-eye view, the bottom of the image is closest in perspective to the viewer. As the eye moves up it also sees into the distance, despite all elements maintaining a consistent size throughout. This is fundamentally different from the rules of Western painting, wherein there is a clear hierarchy of importance distinguishing what is less important from what is more important while also establishing the subject of the painting as a central focus. Where these qualities are characteristic of one-point perspective, the components of Kanō and Yamaguchi's compositions are all treated with equivalence.

狩野永徳 ＋ 山口晃

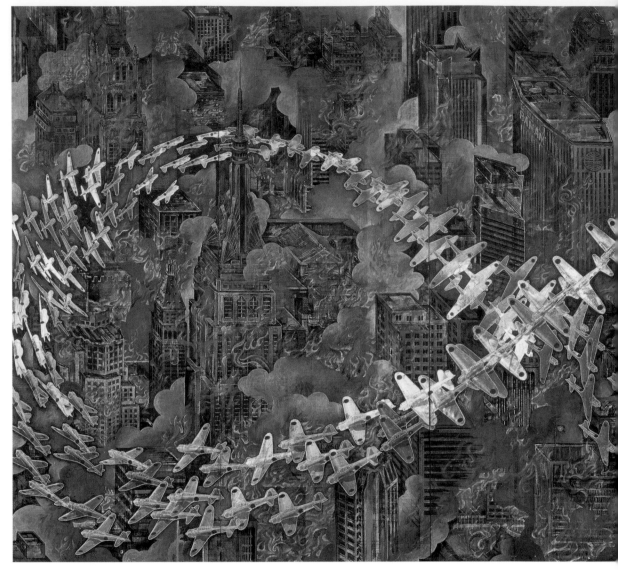

会田誠《紐育空爆之図》（戦争画RETURNS）より

Fig. 5: , *A Picture of an Air Raid on New York City (War Picture Returns)*, 1996. Six-panel sliding screens, hinges, *Nihon Keizai Shinbun* newspaper, charcoal pen, watercolor, acrylic, oil markers. 169 × 378 cm. Private collection. © Makoto Aida. Courtesy of Mizuma Art Gallery, Tokyo.

Taboos and a Code of Traditional Art

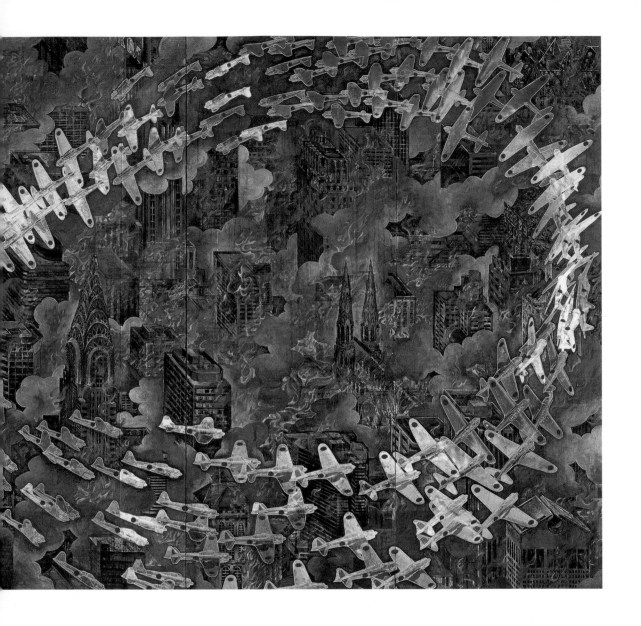

In Makoto Aida's 1996 painting *A Picture of an Air Raid on New York City (War Picture Returns)*, "Zero" fighter planes circle New York City (fig. 5). The Japanese military flew this type of plane on attack sorties during World War II, and in the final days of the war these fighters were used in *kamikaze* attacks. While many cities of Japan were destroyed during WWII, continental America went unscathed and went on to dominate the social, economic, and political landscape of the time. Aida takes an ironic view of this state of affairs, preferring not to ruminate on politics. The bird's-eye view of Aida's composition is typical of traditional Japanese landscapes, such as *Rakuchū-rakugai-zu* (fig. 4), and the skyscrapers are drawn in a manner that follows the conventions of this traditional technique. The fighter planes are reminiscent of mother-of-pearl work—an iridescent effect is created by holographic paper affixed to the work. The arrangement of the planes harks back to the graceful arrangement of the cranes in Sōtatsu Tawaraya and Kōetsu Hon'ami's work (fig. 6) and Matazō Kayama's.

宗達・光悦 ＋ 会田誠

書：本阿弥光悦、画：俵屋宗達《鶴図下絵和歌巻》

Fig. 6: Calligraphy by Kōetsu Hon'ami and drawing by Sōtatsu Tawaraya, *Cranes with Waka Scroll*, 17th century. Paper, gold and silver paint. 34 × 1356.7 cm (detail). Kyoto National Museum, Kyoto. Photograph © KYOTOMUSE

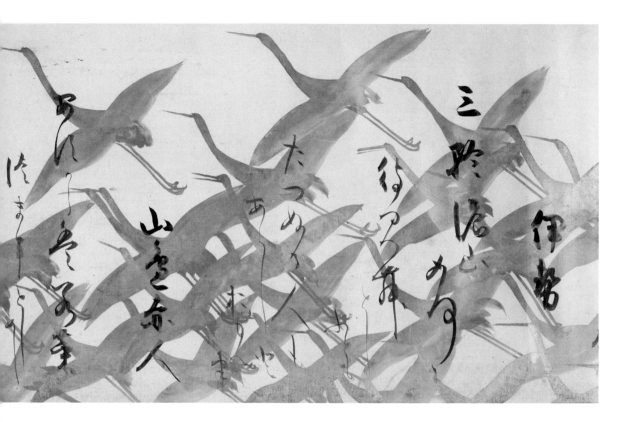

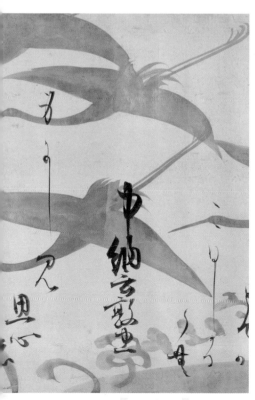

Rimpa in the Modern Age

会田誠《群娘図'97》
Fig. 7: Makoto Aida, *The Girls '97*, 1997. Panel; printed on wrapping paper, acrylic, water-based markers. 116.5 × 364 cm. Private collection. Courtesy of Mizuma Art Gallery, Tokyo.

尾形光琳《燕子花図屏風》(国宝)
Fig. 8: Kōrin Ogata, *Iris Laevigata*, 1701–04. Six-paneled screen; gold leaf on paper. 150.9 × 338.8 cm (each panel). Designated National Treasure in the collection of Nezu Museum, Tokyo.

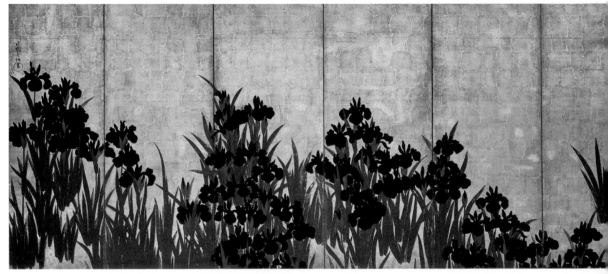

Kōrin Ogata's witty and bold composition (fig. 8) is comprised of a background covered in gold leaf and a palette limited to blue and deep green, which has been simplified to generate a floral pattern. The sequence of irises resembles the notes of a melody on a piece of sheet music. But while the left and right sides of the work have a comparative flatness, the space itself feels limitless and deep. This work is a masterpiece of the Rimpa school that was established in Kyoto in the seventeenth century by Kōetsu Hon'ami (fig. 6). In the Edo period (1603–1868), Kōrin developed this style to an extreme.

Makoto Aida has placed the icon of youthful Japanese femininity, the high school student, in a similar composition of rhythm and decoration (fig. 7). The uniform these girls wear is reminiscent of the Rimpa pattern. In Aida's composition, the background of throngs of people on the street is blotted out, replaced with a decorative gold leaf. The girls, as a result, seem to be adrift. In all of Aida's work, motifs of deformation and abstraction of subject, as well as his themes regarding contemporary society, faithfully inhabit the concerns of Japanese art. Aida has stated, "The basis of my creation is the history of Japanese art." The title *The Girls '97* (*Gunjō-zu*) also borrows its name from the vibrant color of the Kōrin painting *Gunjō-iro*, intentionally and unmistakably calling to mind the older work. (For a fuller discussion of Aida's work see pages 140–143.)

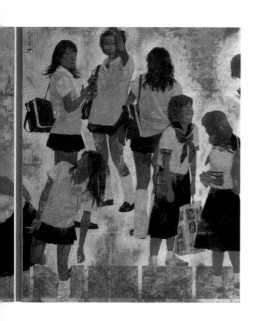

尾形光琳 ＋ 会田誠

Animation in a Cloud

In the scroll *The Descent of Amida* (fig. 9), a Buddha figure accompanied by twenty-five disciples comes from the afterlife to the world of the living to welcome the souls of the dead. Most depictions of Amida's descent show the figure from the front. In this work, however, Amida is seen from the side, descending to earth from the upper left to the lower right, almost slipping down amongst a resplendent scene of cherry trees in full bloom and a rushing mountain waterfall. This gives the composition a sense of speed, which may reflect a common desire among people of the Kamakura period, who hoped for the swift coming of death.

The contemporary equivalent of such expression of movement is found in the refined techniques of manga artists. Of these artists, the most highly respected name is that of Katsuhiro Ōtomo, the author of the legendary *Akira*. This manga earned its reverence with the level of complexity in each of its frames, which meant to encapsulate a sequence of time crystalized as one moment (fig. 10). Though the manga is comprised of still images, all of the elements on the page contribute to a heightened speed of movement, giving the illustrations a mysterious, active quality.

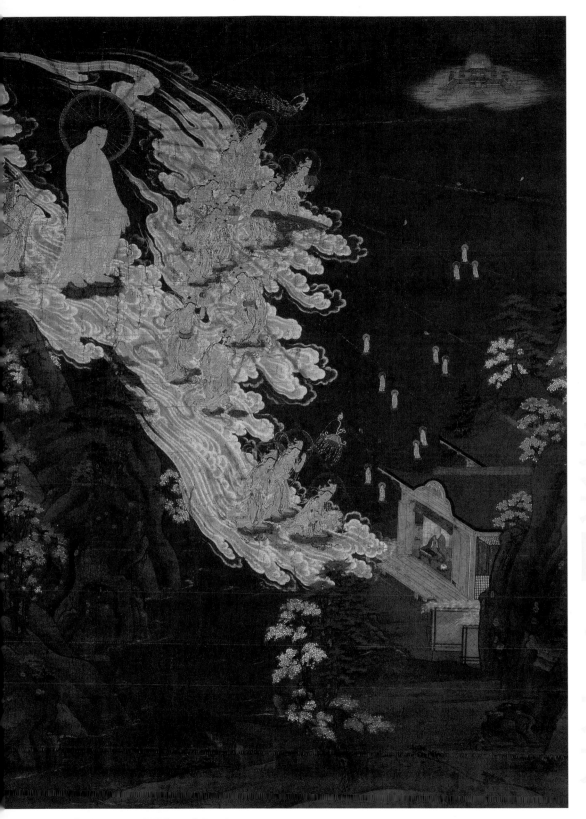

《阿弥陀二十五菩薩来迎図》（国宝）
Fig. 9: *The Descent of Amida, the Buddha of Infinite Light, and Twenty-five Bodhisattvas*, 13th–14th C. Hanging scroll; ink, color, and gold on silk. 145.1 × 154.5 cm. National Treasure in the collection of Chion-in, Kyoto.

来迎図　二十五友兄洋

大友克洋『AKIRA』
Fig. 10: Katsuhiro Ōtomo, *Akira*, 1983–93. © Katsuhiro Ōtomo / Mushroom / Kodansha

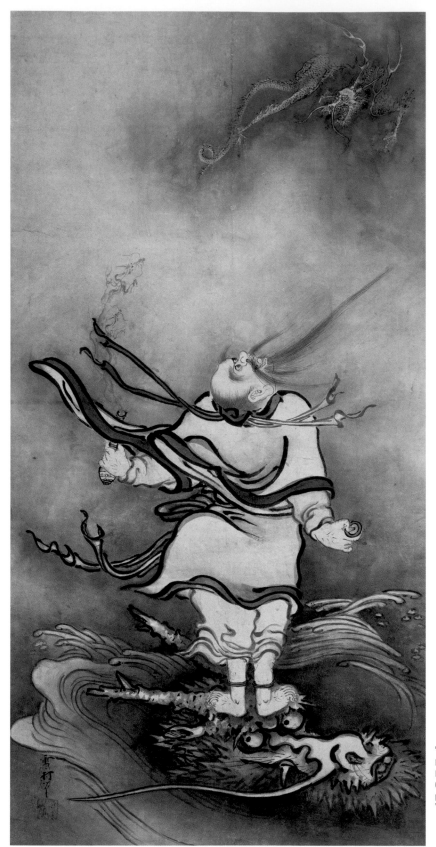

雪村《呂洞賓図》（重文）
Fig. 11: Sesson, *Lu Dong Bin* (Chinese Hermit), Mid-16th C. Designated Important Cultural Property. Hanging scroll; ink on paper. 118.3 × 59.5 cm. The Museum of Yamatobunkakan, Nara.

ミヤケマイ《雨奇晴好》(メゾンエルメス ウィンドウディスプレイ)

Fig. 12: Mai Miyake, *Come Rain Or Shine*, 2007. Mixed media. Window display at Hermès Japon Ginza Flagship Store, Tokyo. © Satoshi Asakawa. Courtesy of Hermès Japon

Eternity in One Image

For contemporary artist Mai Miyake, the appeal of Japan's traditional artistic forms lies in their particular treatment of time. Rather than rendering a moment in stasis, such compositions evoke a sense of the eternal condensed into a single image. Sesson's *Lu Dong Bin* (Chinese Hermit), for example, exhibits such a quality (fig. 11). The holy man, known in Japanese as Ryodōhin, stands atop the head of a dragon. From the jug in his left hand arises smoke, from which another dragon appears.

Miyake borrows this trope for her window display at the Hermès flagship store in Tokyo's Ginza district (fig. 12). A bottle of Hermès perfume is left open with its lid laid beside the work. The fragrance that rises up becomes a carp swimming up a waterfall; a second carp morphs into a dragon in the arduous process of swimming against the river's flow. From out of the composition the dragon flies into the next window, where it dances around in the air.

The commercial context in which Miyake presents this re-rendering of a holy man is a poignant confluence of asceticism and luxury.

雪村十ミヤケマイ

歌川広重《東海道五拾三次 庄野白雨》
Fig. 13: Hiroshige Utagawa, *The Fifty-Three Stations of the Tōkaidō (Shōno)*, c. 1833–1835. Color woodblock print.
24.5 × 36.5 cm. Keio University, Tokyo.

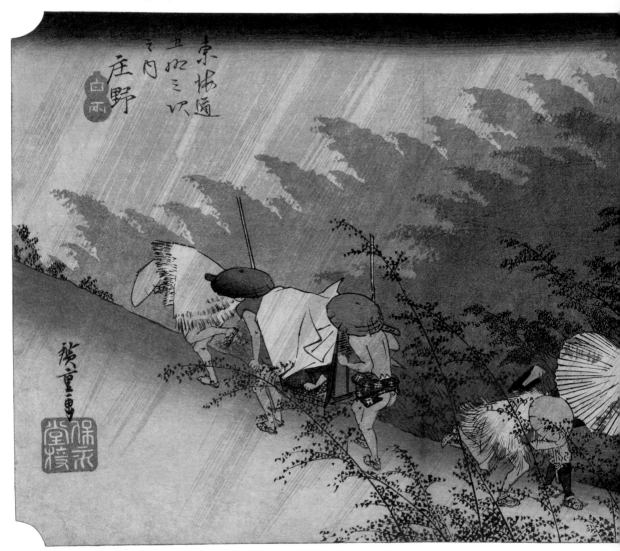

風間サチコ《ガソリンで見た夢》(15点組のうち4点)
Fig. 14: Sachiko Kazama, *Gasoline Dream*, 2001. A series of fifteen prints; panel, washi, China ink. 53.5 × 74.8 cm each. © 2001 Sachiko Kazama. Courtesy of Mujin-to Production.

Cutting Through the Contradictions of Contemporary Society

Sachiko Kazama is a contemporary woodblock artist. Though *ukiyo-e* printing once flourished, her craft has long been considered outdated in Japan. In contrast with drawing by hand, however, Kazama feels that using the woodblock as medium gives the work objectivity. The act of carving injects emotion into the composition, but through printing, the image becomes objectified. Kazama's thematic preoccupations do not play on personal emotions or aesthetics, but rather on contemporary societal issues, or veiled historical problems, such as the makeup of consumer society or corruption in the world of politics. In a series of prints titled *Gasoline Dream* (fig. 14), the pastoral scenes typically found in older woodblock prints, such as Hiroshige Utagawa's *The Fifty-Three Stations of the Tōkaidō* (fig. 13) or Hokusai's *Thirty-Six Views of Mt. Fuji*, have been cut up by highways. Society's current cravings propel the destruction of the landscape.

歌川広重　＋　風間サチコ

Portraits That Make the Invisible Visible

ヤノベケンジ《アトムスーツ・プロジェクト：大地のアンテナ》

Fig. 15: Kenji Yanobe, *ATOM SUIT PROJECT Antenna of the Earth*, 2000. Geiger counter, PVC, strobe light, photography, and other media. 180 × 1480 × 420 cm.

During the Heian period (794–1185), the priesthood was almost entirely reserved for the upper class and nobility. Becoming a Buddhist priest was impossible for commoners. In the tenth century, however, the priest Kūya left a sequestered temple to make a pilgrimage to various parts of the country while chanting the scripture of Namu Amida Butsu. In giving relief to builders of roads, bridges, and temples and involving himself in civic duties, he came to be known favorably as *Ichi-no-hijiri* (priest of the people). With six small realistic figures of the Amida Buddha (cf. fig. 9) at the mouth of this sculpture (fig. 16), this portrait of Kūya in prayer conveys just how unusual this sort of activity was at that time.

In a contemporary sculpture by Kenji Yanobe, *Antenna of the Earth*, the artist overlays his own image onto that of the ascetic monk (fig. 15). Yanobe has said that the artist himself does not make artwork; rather, it is made by the world. Just as Kūya left the cloistered world of the temple to be among commoners, so too does Yanobe's work, which eschews the confines of the art world to rejoin the real world from which it was previously estranged.

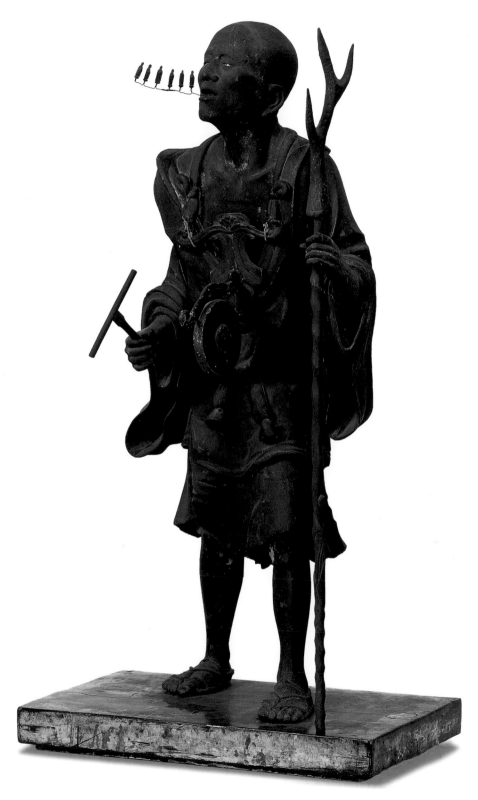

康勝《空也上人立像》(重文)
Fig. 16: Kōshō, *Kūya Shonin*, 13th C. Wood sculpture. Height 117.6 cm. Designated an Important Cultural Property. In the collection of the Rokuharamitsuji Temple, Kyoto. Photograph by Mitsuhara Asanuma.

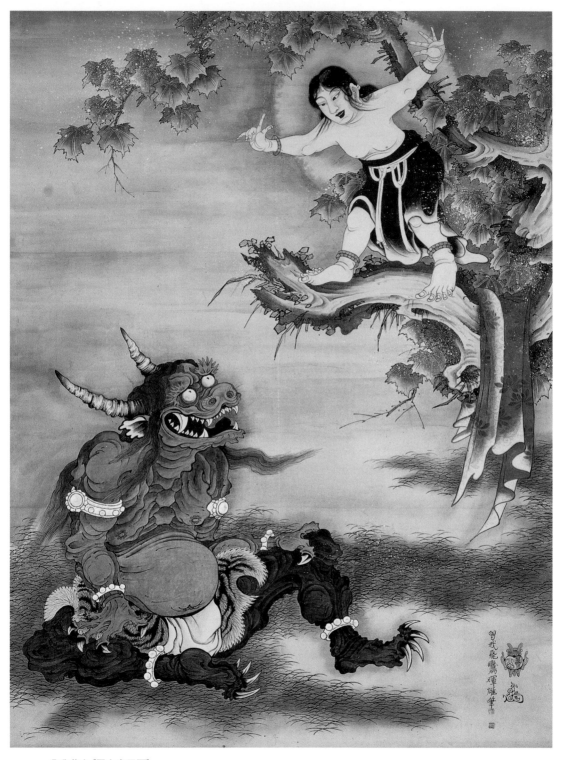

曾我蕭白《雪山童子図》
Fig. 17: Shōhaku Soga, *Sessendōji* (Child of Snow Mountain), ca. 1764. Hanging scroll; color on paper. 170.3 × 124.6 cm.
Keishōji Temple, Mie Prefecture.

The guardian deity Taishakuten appears as a demon to the young Shakyamuni, the historical Buddha who—in the story told by Sheshin Monge—promises to sacrifice himself in exchange for learning *Gaathaa* (scriptural verse that communicates Buddha's good deeds). In Shōhaku Soga's depiction (fig. 17), however, the young Brahmin does not seem threatened by the demon's presence. In fact, his smile belies a trace of arrogance while the demon's form recedes as it looks up in fear. Depictions of the Buddha are generally solemn, making clear the distinction between sacred and profane, good and evil, beauty and disgust, and other such dualities. Shōhaku seems to have abandoned this convention and created a conflated universe that unifies these otherwise oppositional elements. Similarly, Tadanori Yokoo has crafted a universe that transcends duality (fig. 18). In his painting, the spirits of New Orleans cross the ocean while playing flutes to meet the artist in Tokyo. In the top right corner Yokoo has copied the figure of the young boy in Shōhaku's composition while collapsing the distinction between dream and reality, past and future, East and West.

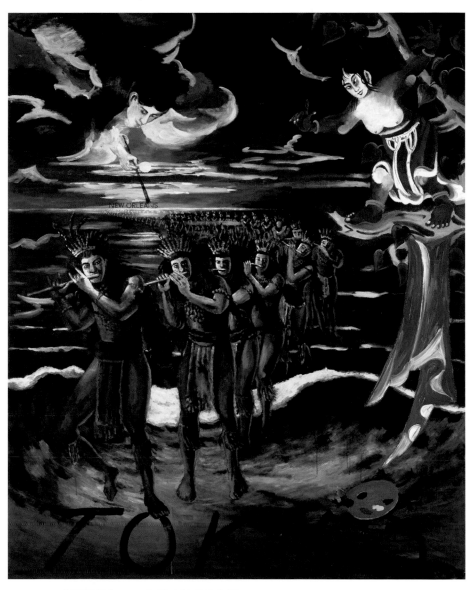

横尾忠則《ニューオリンズからの使者》
Fig. 18: Tadanori Yokoo, *Angel from New Orleans*, 1994. Acrylic on board.
181.1 × 227.3 cm. Collection of the artist.

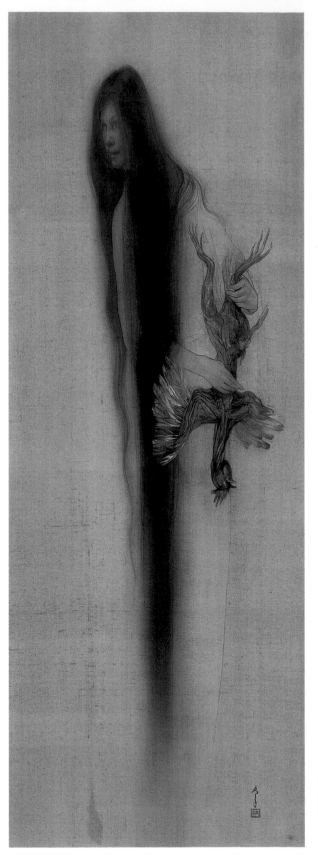

Two Women, Two Ghouls

In Japan, depicting ghosts is its own genre, which comes from the idea of controlling demons by drawing—either as a means of exorcising evil spirits or functioning as a talisman. The drawing was placed in the *tokonoma*, a small alcove typical of Japanese bedrooms and tearooms. After someone's death, the soul can persist in this world and wander about—perhaps prompted by grudge or regret. Ōkyo Maruyama (cf. fig. 28) is credited with establishing the convention of depicting such spirits as legless. Contemporary artist Fuyuko Matsui, who draws *nihonga* (traditional Japanese painting), overlays gloom with femininity. In *Nyctalopia* (Night Blindness; fig. 19) an arm juts out from the hair of the ghost to grasp a bird plucked of its feathers and quartered. The bird resembles a heart ripped from the chest and chopped up.

Shōen Uemura's composition *Honoo* (The Flame of Anger; fig. 20) was inspired by the Noh play Aoi no Ue, which adapts a section from the eleventh-century novel The Tale of Genji. Genji's neglected mistress, Lady Rokujō, is driven mad; her spirit possesses Genji's wife Lady Aoi, eventually resulting in the latter's demise. Lady Rokujō is depicted here wearing a kimono with a bizarre motif of wisteria vines and spider webs, representing the ferocity of her rage.

松井冬子《夜盲症》
Fig. 19: Fuyuko Matsui, *Nyctalopia*, 2005. Silk and paint. 138 × 49 cm. Courtesy of Naruyama Gallery, Tokyo.

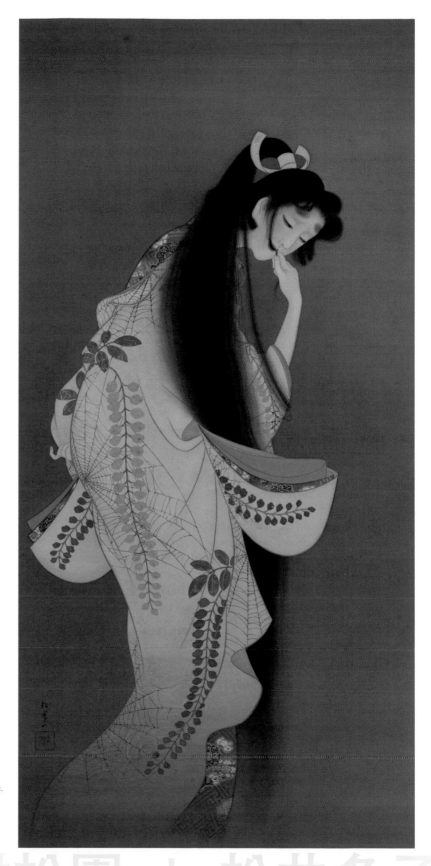

上村松園《焔》

Fig. 20: Shōen Uemura, *Honoo* (Flame of Anger), 1918. Silk and paint. 190.9 × 91.8 cm. Tokyo National Museum. Image: TNMImage Archives. Source: TnmArchives.jp

The History of
Japanese Art Redux

歌川国芳《相馬の古内裏》
Fig. 21: Kuniyoshi Utagawa, *Mitsukuni defying the skeleton spectre invoked by princess Takiyasha*, 1830–44. Three panels: left 37.1 × 25.5 cm, middle 37.3 × 25.2 cm, right 37.2 × 24.1 cm. Color woodblock print. Chiba City Museum of Art.

Inheriting the Legacy of Japan's
Revered Kano School of Painting

Takashi Murakami seeks a connection with and continuation of the history of Japanese art and dismisses the globalism and synchronicity at the core of international contemporary art practices. Since 2000, through publications and exhibitions, he has worked toward this through his "Superflat" project: the "labor of finding the true state and true form of *geijutsu* (craft, as opposed to *bijutsu*, art) on a chart where the vertical axis represents the progression of time in Japanese art history, while the horizontal axis represents all fields of creativity (including manga, animation, fashion, music, etc.)."

Murakami enacts this process not only through this work, but also through "Kaikai Kiki," his collective of artists. The choice of name itself expresses a connection with and a continuation of tradition. Kaikai Kiki is an inversion of the Japanese expression *kiki kaikai*, which means "something weird and ghostly." This switch of order was most notably first made by Sansetsu Kanō's (fig. 22) father, who used it in praise of Eitoku Kanō's painting (fig. 4). The Kanō-ha endured for more than three hundred years and therefore looms large over Japanese art history. Murakami's identification with this school is not only a display of reverence but also describes the system of apprenticeship upon which Kaikai Kiki's model is based.

Murakami explains that "from the perspective of Western contemporary art there was a period when apprenticeship was rejected, but I believe it is suitable for Japan. When I started this enterprise I chose this name to express my intention to indoctrinate an apprenticeship system and to start a form that will continue

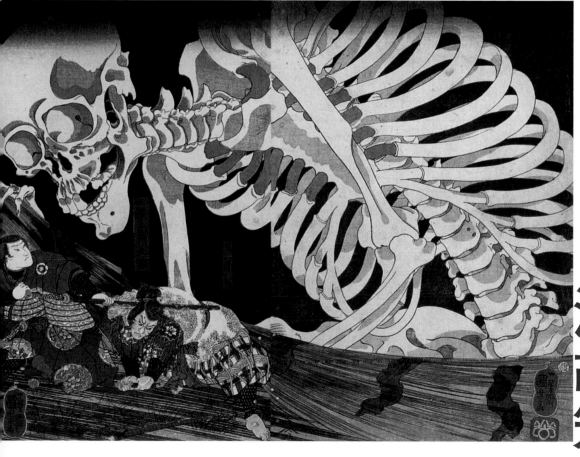

温故知新

狩野山雪《老梅図》

Fig. 22: Sansetsu Kanō, *The Old Plum*, c. 1645 (Edo period). Four sliding door panels (*fusuma*); ink, color, and gold on gilded paper. 174.6 × 485.5 cm. The Harry G. C. Packard Collection of Asian Art, Gift of Harry G. C. Packard, and Purchase, Fletcher, Rogers, Harris Brisbane Dick, and Louis V. Bell Funds, Joseph Pulitzer Bequest, and The Annenberg Fund Inc. Gift, 1975 (1975.268.48a–d).

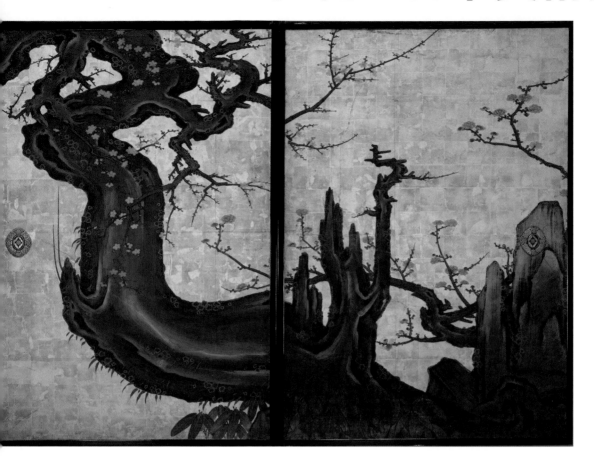

for three hundred years, beginning with my generation." In other words, the name Kaikai Kiki implies a transfer from master to disciple, surpassing generation and era. Murakami is thus restoring and renewing this tradition in a contemporary context, and intends for his project to endure: "From the close of the Edo period and the start of the Meiji era, when Western art was introduced and spread in Japan, Japanese art history suffered an abrupt and decisive rupture," he says. "I want to find out what was lost at that time. And my biggest imperative is to rescue the history of Japanese art once again from Western painting" (March 21st, 2009, panel discussion "Nihon Bijutsu Saikō" [Reconsidering Japanese Art] between Murakami and Nobuo Tsuji held at the Asahi Culture Center, Shinjuku).

Looking at Subculture:
The "Genealogy of a Fantastic Idea"

Murakami first came across the term *kaikai kiki* when he read *Kisō no Keifu Genealogy* (Bijutsu-Shuppan, 1970) by Nobuo Tsuji, a work that revolutionized ideas about Japanese art history. As a student, Murakami was greatly influenced and inspired by this book, which introduced to him Sansetsu Kanō (fig. 22), Jakuchū Itō (fig. 59), Shōhaku Soga (figs. 17, 67), and Kuniyoshi Utagawa (fig. 41). Tsuji's work brought about a thorough reassessment of Edo period painting. In his view, artists who had traditionally been disregarded or considered of secondary importance to the grand schools were in fact avant-garde. He declared the history of Japanese painting to be "no more than the flat and inorganic patchwork organization of schools of painting."

温故知新

Furthermore, while Tsuji was researching his work in the United States, an influential book called *Fantastic, Eccentric Chinese Painting* was released, describing fourteenth- to twentieth-century Chinese painting as "something mystic, magical, and mythic," opening up a new avenue of discussion for Tsuji. "[This] was undoubtedly a contemporary way of seeing art that was using older art to support itself," Tsuji wrote. "That became the basis for my *Genealogy of the Fantastic*."

Murakami was born in the early 1960s, at a time when Japan was enjoying the first tastes of postwar political and economic recovery. Contemporary culture was budding in the form of manga, special effects movies, and animation—all subcultural elements that, for a young boy of that period, more closely reflected the realities of life than Japan's classic arts. Tsuji's *Fantastic Genealogy* revealed to Murakami the connection between creative expression, contemporary subcultures, and traditional expression in Japanese art.

As a student, Murakami was obsessed with animation. "For me animation was a museum of individual paintings," he says. As he sat in the front row of the theater to watch *Adieu Galaxy Express 999* (1981), each cell of the animation was emblazoned on his mind. The production of this animation utilized hitherto unseen special effects, thanks to one legendary animator, Yoshinori Kanada, who was active in the late 1970s and early 1980s. For Murakami, who became obsessed with Kanada's technique, there was a clear connection between Kanada's frames and the gnarled and twisted bough of Sansetsu Kanō's *Old Plum Tree*. It seemed to Murakami that Kanada's special effects were composed by overlaying still images that were based on the complicated composition, lines, and eye directions apparent in a single painting by Sansetsu. In the process of researching Sansetsu, Murakami came across *Fantastic Genealogy*, after which he began to view other artists' techniques similarly, realizing that the connection between Sansetsu and Kanada was not simply happenstance. He believed in a salient connection between expression in Edo period painting and contemporary artistic forms, and that systematizing that connection was entirely possible. "What the artists of the fantastic genealogy were experimenting with has a commonality in principle with the leading of the eyeline as it moves aggressively in four directions within the two-dimensional drawing plane," Murakami said. Murakami's Superflat concept therefore articulates a link between traditional painting styles that reached maturity in the isolationist Edo period and the contemporary Japanese subcultures of *otaku* (obsession with anime, manga, and video games) from the 1980s and *kawaii* (cute) from the 1990s.

A New Beginning:
The Rejection of Western Art

Murakami's advocacy of Superflat was an outright rejection of the principal technique of historical Western painting, the three-dimensional perspective view, which had also exerted a great influence on Japanese art since the Meiji period. Murakami used only the vertical and horizontal axes to render something completely flat, moving the eye of the viewer within the composition by emphasizing surface (figs. 2, 4, 6, 22) to rouse a feeling that something is stepping out of the painting. Murakami explained his ideas regarding surface and movement in composition thus:

"In viewing Shōhaku Soga's work, you face the painting straight on. This is how the artist wants the viewer to encounter the work (and, by extension, the artist). He is asking the viewer, 'How is this?'. Beginning with that engagement of the eyes, the construction of the composition and the eyes' movement all work toward this goal. In Jakuchū Itō's *Colorful Realm of Living Being, Fowls* (fig. 59), only one bird is facing directly forward. All the other birds are facing either to the left, right, up, or down; the viewer's eyes are steered according to the direction of the bird's face. On top of this, the vibrant red of the bird's comb as well as the black of the wings, the yellows and whites, activate the movement of the eye. Since I was a student I have long considered what would make the viewer interested in a painting for a prolonged period. According to the research I have

conducted, without the movement of the eye left-right-up-down and its repetition, the viewer gets bored and moves on. The path the eyeline travels across the two-dimensional surface of the painting and how well it can control that movement is an extremely important problem, I think" (from "Nihon Bijutsu Saikō").

In fact, Murakami's *Tan Tan Bo* (2000) makes extensive use of Jakuchū's head-on engagement. From the eyes in the composition, circles, straight lines, jagged lines, spirals, and various geometric shapes accumulate, along with a complex array of black, red, white, blue, yellow—vivid colors that serve to systematically lead the eye from point to point. There is one problem with this scheme: the viewer must remain locked in place for the composition to come to life. In order to circumvent that problem (and simultaneously parody himself), Murakami made *Tan Tan Bo Puking—a.k.a. Gero Tan* (2002). With this work he was able to maintain the head-on engagement with the viewer, incorporating a spiral composition that directs the gaze within the painting while also allowing for free movement of the eye.

The Topography of Superflat

In *Fantastic Genealogy*, artists who had once been considered tangential to the mainstream of art history were brought center stage, thereby influencing a new generation of artists who also came to re-evaluate their nation's art history. Murakami's Superflat project is a continuation of this engagement, as it positions subculture within the context of high art. Starting with the 2001 exhibition Superflat (originated by the Museum of Contemporary Art, Los Angeles), a three-part series that concluded in 2005 with Little Boy: The Art of Japan's Exploding Subculture (held at The Japan Society, New York), Murakami forged a new direction in Japanese art. Art critic Midori Matsui described the project thus: "Aesthetically, Superflat demonstrates Murakami's nationalist challenge to the hegemony of modern Western art by asserting standards of creation and appreciation derived purely from Japanese resources" ("From Pleasure Room to Chaotic Streets," in *Little Boy: The Arts of Japan's Exploding Subculture*, Yale University Press, 2005). With Superflat Murakami is not only proposing a composition based on head-on engagement with the viewer, directed gaze, and other such formal concerns, but he also extends Superflat to indict the culture and social environment around Japanese contemporary art, in which high art and subculture are equal. Murakami is seeking a post-hierarchical field in which society, its customs, *geijutsu* craft, and culture all exist in a super-two-dimensionality.

Superflat collapses such dualities of high vs. low, uniqueness vs. multiplicity, and art vs. craft. In flattening hierarchies, Murakami is attempting to liberate Japanese contemporary art from the spell of its Western counterpart, upending views of his country's place in art and in the world. Murakami opened his Superflat manifesto with the line "Japan may be the world's future," but the origin of that "future world" is rooted in a fantastic genealogy, one that can only be found in Japan's past.

温故知新

第 2 章

間

SPACE

(*ma*)

Between a Rock and Empty Space

There is no English equivalent for the word *ma*. It can be defined as the *setting* between object and object, person and person, or person and object; it can also refer to an atmosphere or situation. It can extend to more nebulous parameters, such as the space between or even the emptiness between things, or it can denote a breadth of settings within the context of a lifestyle. It encompasses formlessness too, as a possible configuration in the aesthetics of space.

A closely related term, *shitsurae* (which is most close to "setting"), became a prevalent technique from the 1970s onward, resembling the idea of installation. Not restricted to a particular genre, it was used across the board, becoming a composite art form within painting, sculpture, film, photography, music, and performance. Using a particular space or place for an installation, that exhibition became site-specific.

Even in installation we can trace an aesthetic heritage in Japan. In the sixteenth century this art form was systematized as *wabi-cha* (a style of tea ceremony—*wabi* for forlorn and *cha* for tea, pages 54–55). From the waiting room to the connecting lane, along with its stepping stones, the tea room, a small side gate, a hanging scroll, flowers, charcoal, the kettle, and bowls, the individual value of each element is not sufficient; the uniqueness of each is emphasized, maintained, and balanced by the harmony of all elements, generating one space. In medieval times, centuries before "art" as understood in the West had yet to be introduced to Japan, the methods of sophisticated contemporary art were practiced in *wabi-cha*.

Installation for a Sole Guest

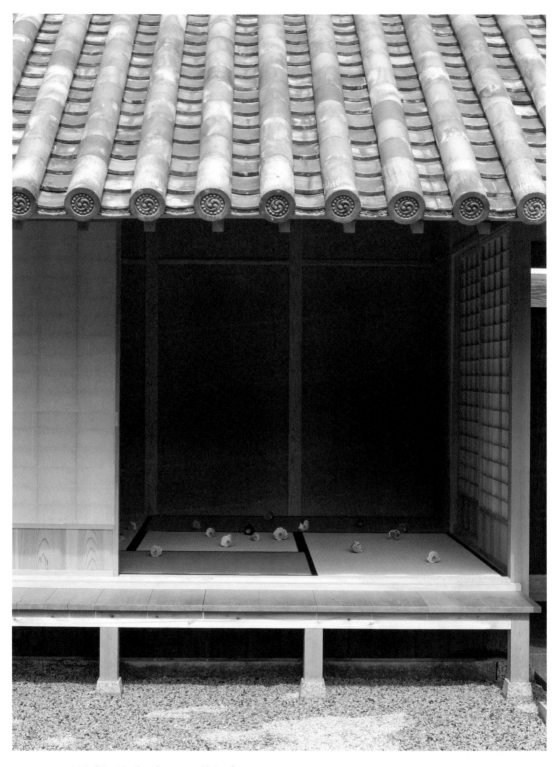

須田悦弘《椿／家プロジェクト　碁会所》
Fig. 23: Yoshihiro Suda, *Go Player's Club*, 2006. Bennese Art Site Naoshima, Fukutake Art Museum Foundation.

千利休《待庵》(国宝)

Fig. 24: *Tai-an* tea room of Myōkian tea house by Sen no Rikyū, late 16C. Kyoto.
Designated National Treasure.

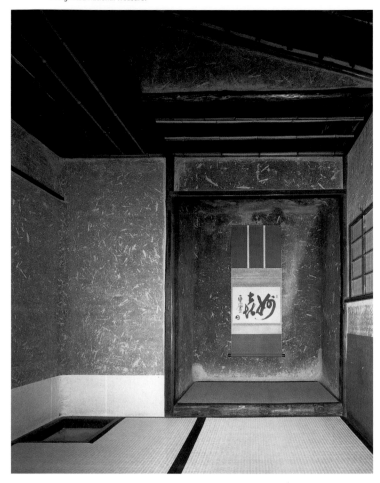

Yoshihiro Suda makes wooden sculptures in the shape of flowers that are so lifelike
and painstakingly realistic in detail that they are often mistaken for the real thing
(fig. 23). But sculpture itself is only one element of the production. Suda pays
attention to where the flower is *planted*, where its roots would extend, and how the
exhibition space itself—in its neutrality—supports the *life* of the work as a whole. Suda
has made specific reference to Sen no Rikyū, who is considered the founder of *wabi-
cha*, regarding this approach. In particular, he points to a famous "Morning Glory Tea
Ceremony" to which Sen no Rikyū invited the warrior Hideyoshi Toyotomi, an important
figure in advancing the arts of the sixteenth century. Before Hideyoshi's arrival, Sen
no Rikyū cleared an entire patch of morning glories from his garden. When Hideyoshi
arrived to see a garden so unkempt, he became utterly enraged. It was not until he
entered the tea room, where he was met by a single morning glory that Sen no Rikyū
had planted in the floor, that he realized the tea master's intention. Similarly, Suda, in
his installations, looks to these origins, bringing the attentive offices of the tea master
into the context of contemporary art.

千利休十須田悦弘

The Japanese Garden and the
Aesthetic of Subtraction

《石庭》
Fig. 25: Rock garden of Ryūanji Temple, Kyoto, c. 1499 (Muromachi period).

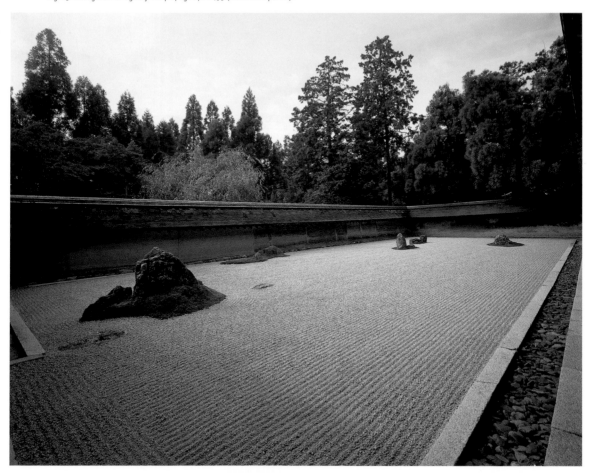

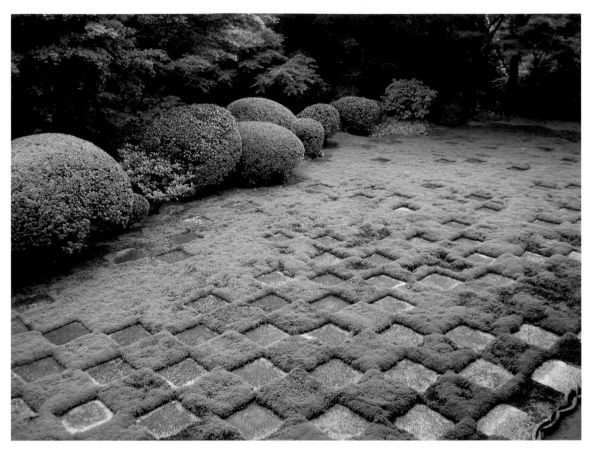

重森三玲《東福寺方丈庭園》
Fig. 26: Mirei Shigemori, north garden of Tōfuku-ji Temple, Hōjō, Kyoto, 1939.

Ma in Japanese can also relate to *negative* space in Western terms. Artist Mirei Shigemori held great respect for the idea of *ma*. Known as a gardener of the Shōwa period (1926–1989), he started out as a painter but became known for his revolutionary work with *ikebana* (flower arrangement). The breadth of his artistic associations was considerable—including friendships with photographer Ken Domon and sculptor Isamu Noguchi—as was the reach of his talents: he was adept with painting, sculpture, traditional Japanese gardens, architecture, craft, and *iwakura*, primitive stone assemblages functioning as repositories for deities. Shigemori's central pursuit was finding an expression of harmony among these disciplines. Influenced by the Sangaku Shinkō faith (page 105), Tumulus culture, Buddhism, and Chinese culture, Shigemori searched for a newness that was an eternal modernity. He established gardening as an art of relations, notably in his abstract configuration of stone and moss squares in the north garden of Tōfuku-ji Temple in Kyoto (fig. 26). This garden is a revival and re-rendering of *karesansui*, an aesthetic of subtraction. Without the use of lakes or flowing water, a garden made of rocks and combed sand recreates the flowing waters of the mountains—a prime example of which is Sekitei Ryūanji, or the rock garden of Ryūanji Temple in Kyoto (fig. 25).

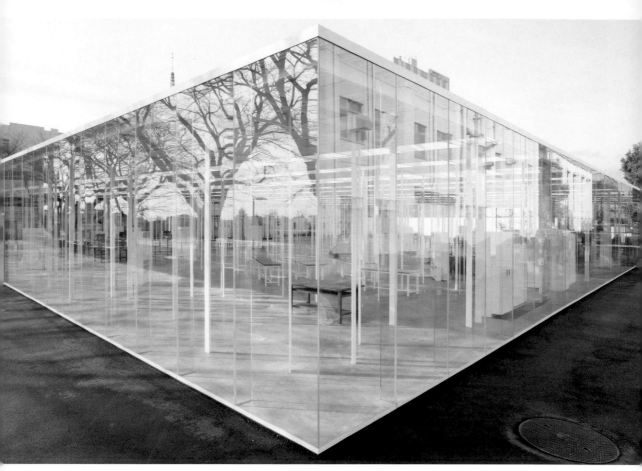

石上純也《KAIT工房》

Fig. 27: Junya Ishigami, Kanagawa Institute of Technology (KAIT Kobo), 2008.
Photography by Iwan Baan.

Borrowing Landscapes

One of the techniques of Japanese gardening is *shakkei*, meaning "borrowed view." As implied by the name, such a garden makes use of the surrounding landscape in its design; it is simultaneously a sculpture and a view. Ōkyo Maruyama invoked this precept of gardening on the illustrations of his sliding doors. Inside Kotohira-gu Shrine (fig. 28), Ōkyo has drawn a dragon poised so that when viewed from a certain angle and when all the sliding doors are open, the clear water of the garden's pond seems to flow through the center of his composition. Architect Junya Ishigami's construction is also a *shakkei* (fig. 27). The glass on the façade of the building has a reflective quality, thereby wrapping itself in the environment that surrounds it. The highly permeable glass wall does not establish a distinction between inside and outside, but communicates a fluid continuity. The slender columns randomly arranged inside the building are like trees, and the skylight functions like a patch of sun shining through the canopy of a forest. The space within and the surrounding nature call out to each other.

円山応挙《瀑布図》(写真中央奥)
Fig. 28: Ōkyo Maruyama, landscape illustration, waterfall illustration, Edo-period (1794), installed in the Kotohira-gu Shrine *shoin* known as *Sansui no ma*.

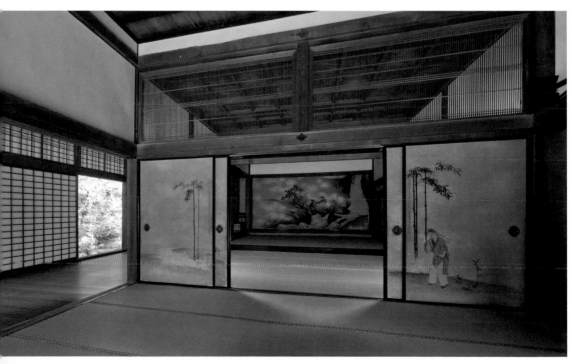

Flipping Negative and Positive

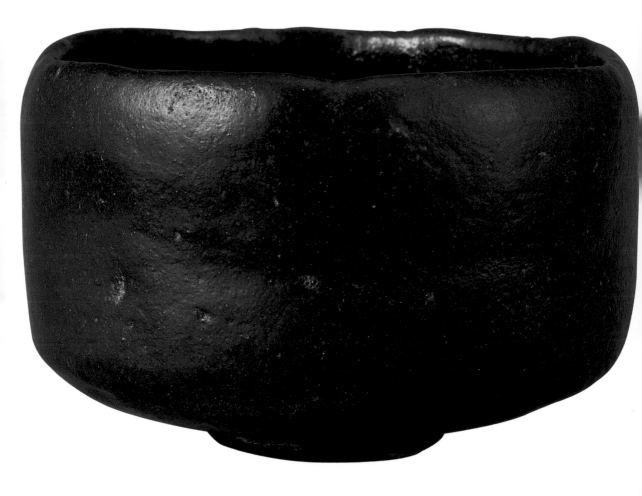

長次郎《黒楽茶碗 銘「俊寛」》
Fig. 29: Chōjirō, Black Raku-ware bowl. Azuchi-Momoyama period (16th century). 8.1 × 10.7 cm.
Mitsui Memorial Museum.

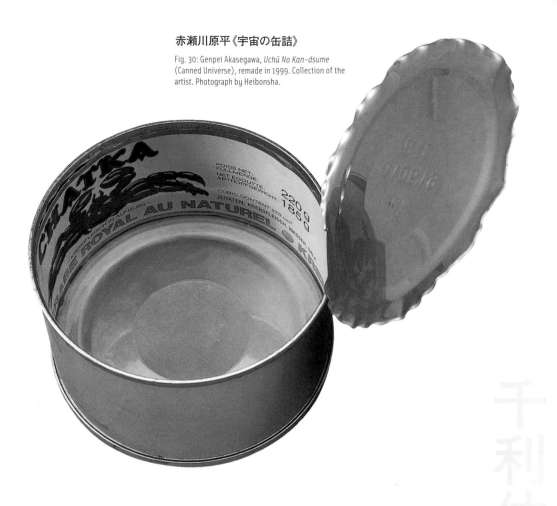

赤瀬川原平《宇宙の缶詰》

Fig. 30: Genpei Akasegawa, *Uchū No Kan-dsume* (Canned Universe), remade in 1999. Collection of the artist. Photograph by Heibonsha.

千利休 十 赤瀬川原平

In the Azuchi-Momoyama period (1573–1603), imported teaware, particularly tea bowls, were in vogue. This was a time when high culture was in full bloom. Ceramist Chōjirō of the Raku line of potters brought revolutionary change to the design of such bowls by infusing them with the aesthetics of *wabi-sabi* as espoused by Sen no Rikyū (page 55). For Sen no Rikyū, the "nothingness" of Zen Buddhism and the "isness" of Taoism were principal tenets of the tea ceremony. Chōjirō's bowls were hand-formed half-cylinders lacquered black. The impression they left was decidedly crude. His complete elimination of ornament established him as an avant-garde artist of the time.

From the late 1950s until the 1960s, the avant-garde artist Genpei Akasegawa, best known for his work *Sen'ensatsu Kakudai-zu* (Enlargement of the 1,000-yen note), proposed similarly revolutionary ideas. In postwar Japan, taking the lead from America's large-scale consumer society, the basis of capitalism was the value of money. In the same period, Akasegawa also started a series in which he wrapped everyday items in craft-wrapping paper. The culmination of that series is *Uchū no Kandsume* (Canned Universe). Just as Chōjirō's bowl placed the nothingness and "isness" of the universe in the palm of the hand, Akasegawa has also created a work that holds the entire universe at once, in an opened tin can.

Designless Design

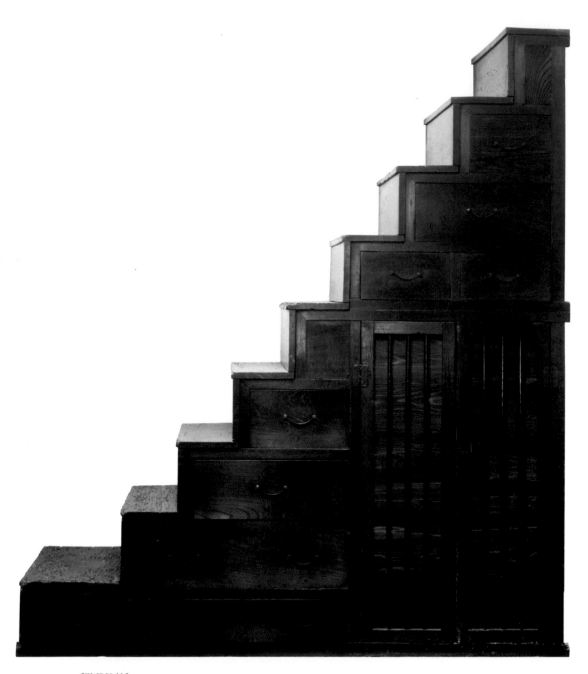

《階段箪笥》
Fig. 31: Cupboard chest of drawers, early Meiji-era. Collection of the Fuchu Museum of Furniture and Woodworks.

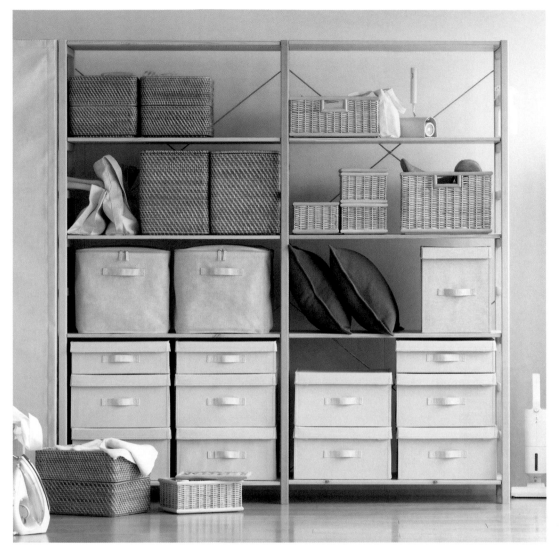

無印良品《収納》

Fig. 32: Mujirushi Ryōhin, storage units, 1980s. Ryōhin Keikaku.

The hyper-consumerism and rapid economic expansion enjoyed by Japan in the 1980s eventually plateaued once the nation's households were thoroughly outfitted with an excess of items. In such heady times, Mujirushi Ryōhin, more commonly known as Muji, presented a counterproposal with its simply packaged, sensible products (Mujirushi Ryōhin translates as "no brand, good product"). Muji made extensive use of basic materials that were largely unprocessed and untreated to create standard household items freed of an overt design (fig. 32). With a design principle that takes subtraction to an extreme, Muji was able to tap into a Japanese sensibility for the plain and pure.

The Japanese respect for the simple is exemplified by a medieval lyric that praises the *wabishii* (lonely or forlorn) timber shack that still had bark on its wood when Emperor Shōmu visited the residence of the politician Nagaya-ō. Using materials as they are found also links back to the architecture of Shintō shrines and *wabi-cha*. A Meiji-period cupboard doubles as a flight of stairs, with drawers in the steps, making full use of limited available space. Muji takes the same modular approach to its products, which are sized to fit the particular *madori* (space configuration) of a Japanese home.

民具 ＋ 無印良品

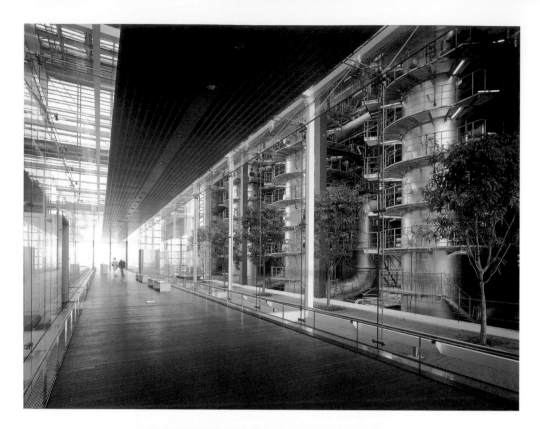

谷口吉生《広島市中工場》
Fig. 33: Yoshio Taniguchi, Naka waste incineration plant, 2004. Waste treatment facility in Hiroshima.
Photograph by Shunji Kitajima.

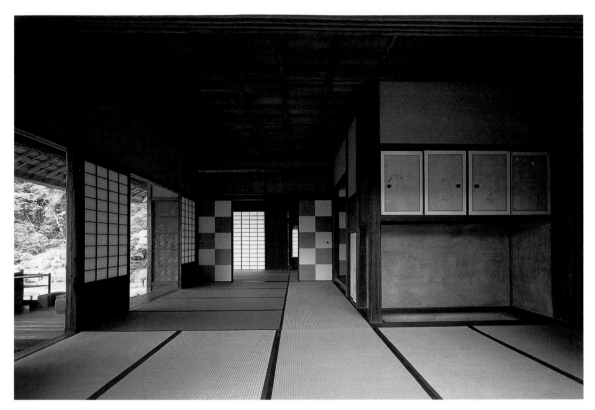

《桂離宮》
Fig. 34: Katsura Rikyū, *Kyoto*, early 17th century (Edo period). Kyoto.

桂離宮 十谷口吉生

The Beauty of Controlled Proportions

German architect Bruno Taut praised the imperial villa Katsura Rikyū (fig. 34) as a miraculous architectural specimen. Bauhaus pioneer Walter Gropius admired it for its balance of endless simplicity. During the early Edo period (1603–1868), in which power was centralized under samurai rule, Hachijōnomiya Toshihitoshinnō and his son Toshitadashinnō devoted half their lives to erecting this edifice in Kyoto. In the same era, the Tokugawa family built the Tōshōgū in Nikkō (fig. 40), which took a baroque approach to ornamentation and poses a stark contrast to the simple composure of the Katsura. The beauty of the latter lies in its highly refined sense of proportion.

The architecture of Yoshio Taniguchi is similarly characterized by minute calculations, and control of each and every horizontal and vertical line to create a peaceful space. His design for a waste incineration plant is no less a study of equanimity (fig. 33). "I inspected a lot of other such facilities throughout the world and found that in most cases, the building was designed in a way to make itself invisible and go unnoticed. But for me, such a facility is a necessity in a contemporary city, so I also expressed that with the outer design of the plant." Taniguchi has been involved in numerous architectural projects for museums in Japan, and in 2004 he was responsible for the renovation of the Museum of Modern Art, New York.

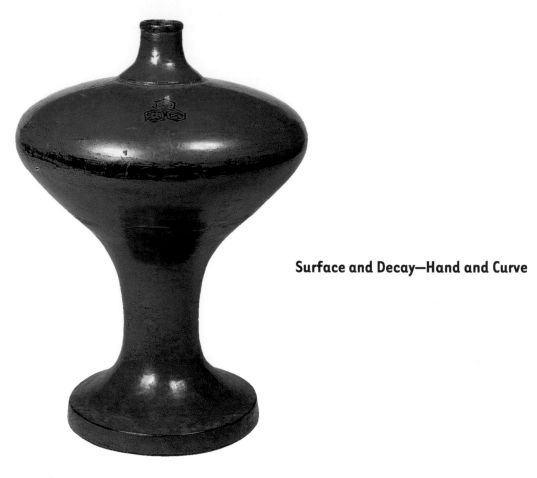

Surface and Decay—Hand and Curve

《根来亀甲文瓶子》
Fig. 35: Negoro flask with turtle shell symbol, Muromachi period.
Wood and lacquer. Hosomi Museum, Kyoto.

The work of industrial designer Sōri Yanagi has one central tenet: design with the palm of the hand. The organic shapes characteristic of Yanagi's products result from the grasping and kneading action of the hand, as seen here in his legendary Butterfly Stool (fig. 36). A large number of his designs begin with a model made from gypsum, and through an extensive trial process he arrives at a final form. Such design work cannot possibly be made from a plan on paper—the supple curves come from the gesture of the palm stroke. This connects to the ideas of the designer's father, Sōetsu, who was a pioneer of Japanese cultural studies and established *mingei* (Japanese folk crafts) as a legitimate topic of research and study.

The forms of *mingei* items do not have the petrified uniformity of mass-produced items that have been fashioned to maximize production efficiency. The use and weathered quality of these well-crafted items magnifies charm. This is also true of the vermilion-colored lacquer *Negoro-nuri* (fig. 35). Over time the exterior lacquer begins to wear and reveal the black lacquer underneath. This aging process reveals the depth of the lacquerware, reflecting the beauty and hidden complexities of everyday life.

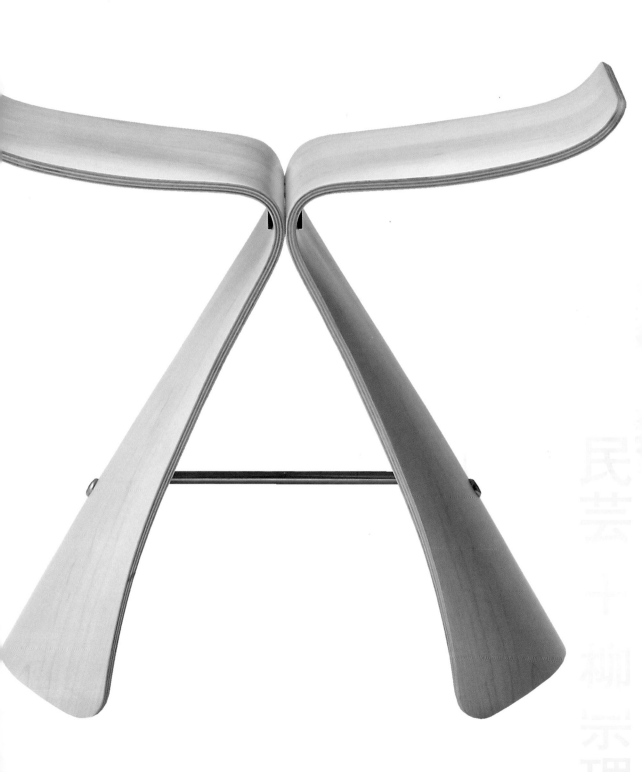

柳宗理《バタフライスツール》
Fig. 36: Sōri Yanagi, Butterfly Stool, 1956. Maple. 38.7 × 42.5 × 31 cm.
Photograph by Yanagi Design Institute and Tendo.

傾

KABUKI

A Touch of Kitsch

Most English readers will recognize *Kabuki*—written with the characters 歌舞伎—as an elaborate, theatrical dance. This is an adaptation of an earlier meaning of the term *kabuki*, "to tilt the head," referring to something off-register or unconventional. The origin of the mindset of *kabuku* lies in the disregard of function in favor of excessive ornamentation. The verbal form of the term *kabuku* came into use in Japan's Middle Ages, but this notion also can be attributed to Jōmon period earthenware. *Kabuku* later emerged in the form of *basara* or *kabuki-mono*, essentially outlaws and rule-breakers. In art and design, this is typified by extreme embellishment, irrationality, "outlaw aesthetics, kitsch, and extreme customization," and was popular in Japanese *Yankee* culture from the 1970s. While Japan's *wabi-sabi* aesthetic sense emphasizes the arrangement of simple elements in a highly controlled and restrictive manner, its flip side can be seen in this baroque and passionate form.

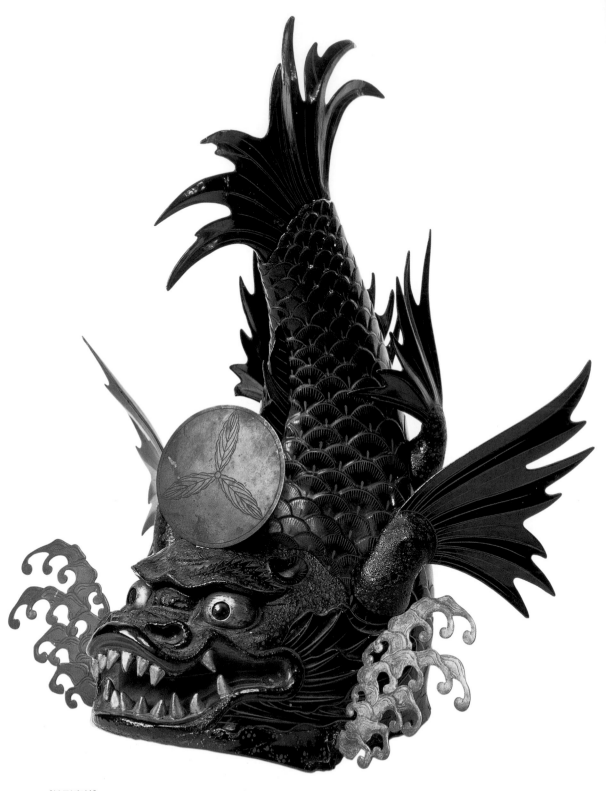

《鯱形兜鉢》
Fig. 37: Whale-shaped helmet. 47.4 cm. 17th C. Kozu Kobunka Museum.

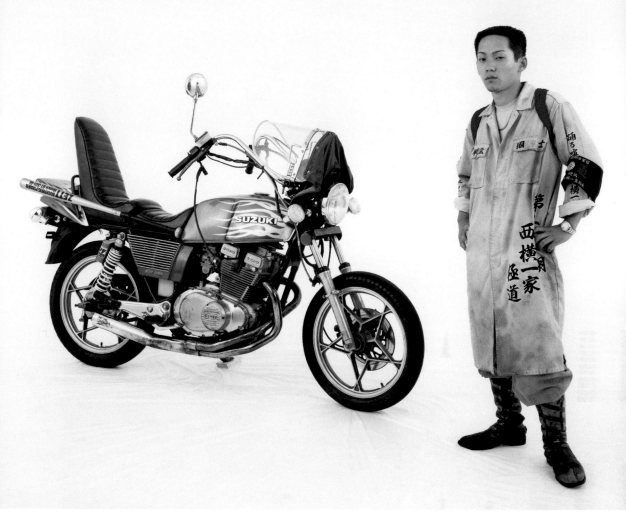

吉永マサユキ《族》

Fig. 38: Masayuki Yoshinaga, "Zoku", 2003. Cibachrome print. Collection of the artist.

The upturned fish (fig. 37)—with its naturalistic scales and fins, and projecting the fearsome look of a killer whale—is an object of refined sensibility. But this was also a helmet worn by a warrior in battle. Originally, helmets functioned solely as protective headgear, but in the fourteenth and fifteenth centuries military commanders began wearing adorned and foppish articles, generically known as a *kawari kabuto* (substitute helmet). Not only would they be a disadvantage in battle, but they also seem to reduce almost any conflict to one of aesthetics. In the protracted warring-states period of Japan's history (from the mid-fifteenth century to the early seventeenth century), it became customary to display the fighting spirit of the commanding generals in a decorative fashion. The helmet shown here is a design fabricated in the Edo period.

In contemporary times, this tendency can be seen in *Yankee* fashion (*Yankee* in Japanese comes directly from the English word but it means "derelict" or "thug"). They sport exaggerated hairstyles and clothes resembling *ginbaori* and *nobori* (extremely long coats), which are adorned with motifs of dragons, tigers, giant snakes, or other such ferocious animals. Motorcycles, cars, and trucks can also be given a similar work-up, giving them an unmistakable presence, as in this photograph by Masayuki Yoshinaga (fig 38).

Encrusted with Decoration

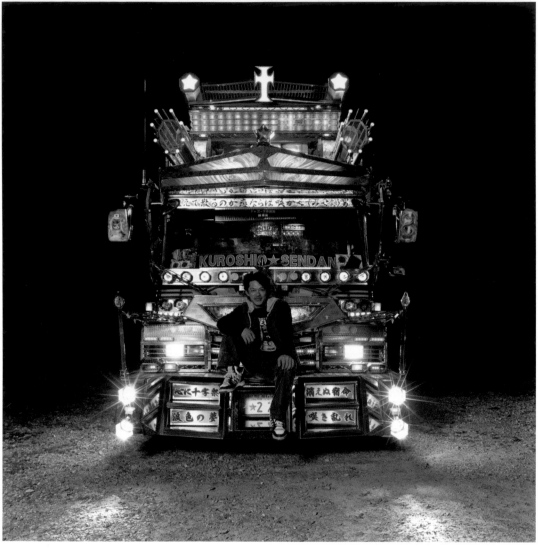

田附勝《龍虎丸 宮内龍二 茨城》

Fig. 39: Masaru Tatsuki, *Deco-Tora*, 2004. Cibachrome print. Collection of the artist.

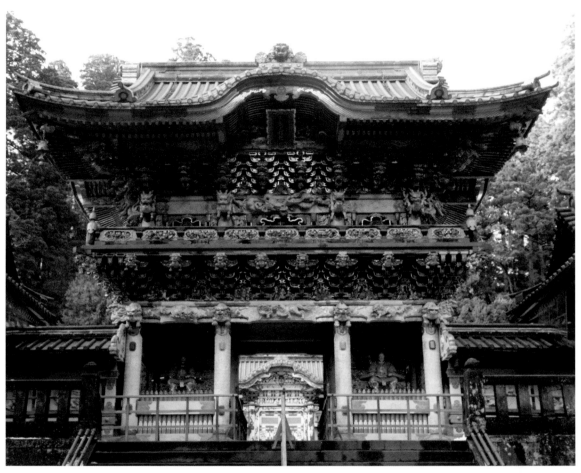

《日光東照宮陽明門》（国宝）
Fig. 40: *Yōmei-mon* (Sunlight Gate), Tōshōgū in Nikkō, Early 17C (Edo period). Tochigi. Designated National Treasure.

Commonly known as *Higurashimon*, the Tōshōgū in Nikkō (fig. 40) was built in the early Edo period, in a style evocative of all that was de rigueur in architecture, sculpture, and decoration at the time. At both ends of the cusped Chinese gable in the gate's eaves there are five hundred sculptures of people, sacred beasts, plants, and patterns—an overabundance of detail and decoration. Inlaid into the roof is a dragon figure symbolizing strength and nobility, bespeaking a new peace under the rule of the first Tokugawa shogunate—Ieyasu—for whom this was built as an homage following his death in 1616. Emerging from a lengthy period of war spanning more than 150 years of political turmoil and social upheaval, unification marked a great change in the order of all facets of society; shogun were elevated to the status of gods, necessitating intimidating and arresting visual appeal, and displays of their authority and power to their legions. In contemporary times, the decoration truck (shortened to *deco-tora*; fig. 39) inherits the legacy of the Tokugawa Ieyasu, serving as castle on wheels, exhibiting a baroque *Yankee* mentality. This level of ornamentation surpasses function and efficiency, but is seen as a display of a man's pride and mettle.

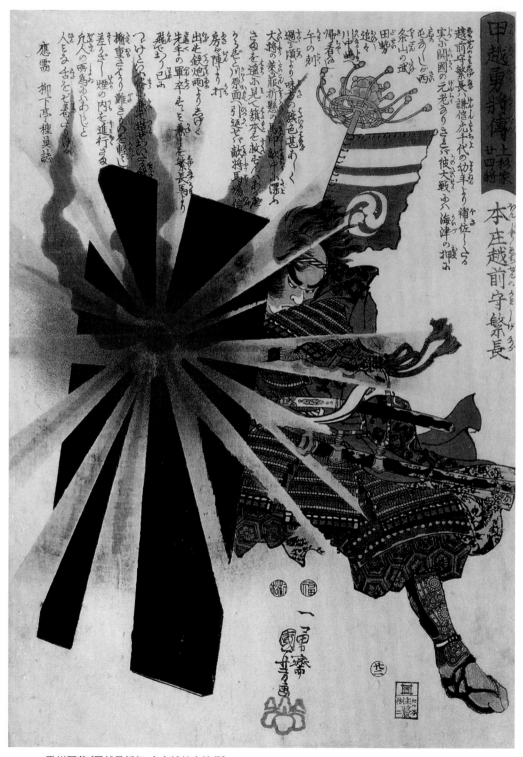

歌川国芳《甲越勇将伝 本庄越前守繁長》

Fig. 41: Kuniyoshi Utagawa, *Honjō Shigenaga Parrying an Exploding Shell*, Late Edo period. Woodblock print.
Photograph: visipix.com

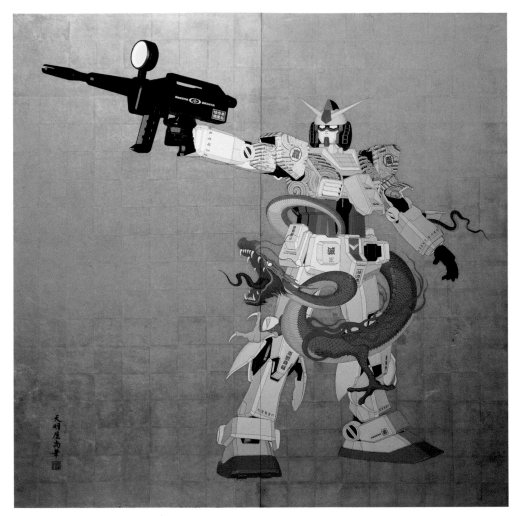

天明屋尚《RX-78-2 傾奇者 2005 Version》

Fig. 42: Tenmyouya Hisashi, *RX-78-2 Kabukimono 2005 Version*, 2005. Acrylic, gold leaf, wood. 200 × 200 cm.
© Sotsu Sunrise © 2005 Tenmyouya Hisashi. Courtesy of Mizuma Art Gallery.

Appropriating the posture of brave shogun, Tenmyouya creates a contemporary version of the *musha-e*, a popular subject of *ukiyo-e* depicting a warrior in battle (fig. 42). But in the role of the warrior he has cast a character from a present-day cult-classic anime, *Mobile Suit Gundam* (1979 to present). Tenmyouya not only adopts traditional techniques and styles in representation, but also inherits the antiestablishment spirit of warriors such as the Basara of the Muromachi period or the Kabukimono of the Edo period. The tale of heroism depicted in this work by Kuniyoshi Utagawa (fig. 41) is of a senior statesman, Honjō Shigenara, who served as prime minister under Uesugi Kenshin. Apart from these *musha-e*, Kuniyoshi also drew apparitions and wild beasts, and *yose-e* (miniature figures of people that depict parts of the face, similar to Archimboldo's portraits in fruit and vegetable), or the anthropomorphization of animals through which he made arch satire of members of society. If his contemporaries, including the artists Utamaro and Hokusai, belonged to the orthodoxy, Kuniyoshi was definitely heretical. It was not until the latter half of the twentieth century that his work came to be recognized as a unique artistic contribution to the last days of the shogunate.

Form and Ornament on Mobile and Immobile vehicles

中村哲也《プレミアム・ユニット・バス》
Fig. 43: Tetsuya Nakamura, *Premium Unit Bath*, 2003. Urethane coating, FRP.
200 × 90 × 130 cm. Courtesy of Wacoal Art Center, Tokyo. Photograph: Katsuhiro Ichikawa.

《黒塗二葉葵唐草葵牡丹紋散蒔絵女乗物》

Fig. 44: Ceremonial palanquin (*norimono*), 1856 (Edo period). Lacquer and gold on wood; interior paintings: ink, color and gold on paper; blinds: bamboo and silk. 128.9 × 477.6 × 96.8 cm. Arthur M. Sackler Collection, Smithsonian.

Tetsuya Nakamura imbued the abstract idea of speed in this bathtub masquerading as an immobile racing car (fig. 43). It is reminiscent of sensual gold and silver lacquerwork and composed exclusively through traditional craft techniques. Nakamura's figurative sense of ornamentation and form is evocative of Edo-period palanquins, portable palaces that represent—in a concentrated form—the period's refined aesthetics. This palanquin (fig. 44) was used in the wedding ceremony of the Tenshōin, the legal wife of the Tokugawa Iesada, the thirteenth shogun of the Tokugawa shogunate, who was in power for only five years (1853–1858). From the main cabin to the beams of the palanquin, the structure is encrusted with fine gold and silver lacquerwork of vines and hollyhock. Even the interior is covered with gold foil, pine, and cranes—symbols of celebration. Such decorative expression is an embodiment of the strictly regulated social system of the period.

Silent Requiem for the
Beauty of Weapons

榎忠《RPM—1200》
Fig. 45: Chū Enoki, *RPM–1200*, 2005. Industrial wastage. Installation at the Mori Art Museum.
Courtesy of YAMAMOTO GENDAI, Tokyo.

《金銅密教法具》（国宝）

Fig. 46: Set of gilt bronze esoteric Buddhist ritual implements, Kamakura period
(13th century). Designated National Treasure. Itsukushima Shrine, Hiroshima.
Photograph by Nara National Museum, Kinji Morimura.

Since the 1970s, Chū Enoki's extreme performances and appropriation of guns and
artillery to create enormous art objects have been a continual cause of controversy. His
objects have an overtly aggressive quality: "The work expresses man's drive to create
and possess murderous weapons, the victims of which are the living beings who created
such tools. Brutality and foolishness are conflated with desire—I wanted to express that
paradox of the human condition." *RPM-1200* is made of discarded factory scrap metal
that Enoki painstakingly polished and arranged so as to resemble a missile factory
(fig. 45), but the feeling of solemnity evoked closely resembles the awe inspired by
the myriad gold-covered Buddhist altar fittings made in the dominant style of the latter
part of the Heian period and the Kamakura period (fig. 46). For the devout, statues and
reflective gold decoration in Buddhist and Shintō holy spaces were a symbol of faith. In
this way, the grace and beauty of the altar fittings themselves are a requiem for the Pure
Land of Ultimate Bliss—a Buddhist sect which is prevalent in Japan.

景

DIORAMA

(*kei*)

Remaking Nature

Depiction of nature in Japanese art can be highly artificial; landscapes are imbued with an emotional tone that determines their composition and are praised for this quality rather than verisimilitude to nature. Nature is reconstructed rather than reproduced, as is evident in the work of *sansui* ink-and-wash drawing master Sesshū (fig. 55), who abstracts the slopes of mountains and cliffs with his brushstrokes. In Tōhaku Hasegawa's *Pine Forest* (fig. 47), the trees are obscured and their color subdued by a thick fog, representing the untimely death of his son. Even drawings of delicate grasses, birds, and flowers evoke an extreme unnaturalness (figs. 49, 52, 54). Individual subjects are not simply deformed and represented in two dimensions; within a single composition we can also see the progression of the four seasons—*shiki kachō-zu*, paintings of flowers and birds representative of each season. In such a "serial" picture, the progress of time through four seasons in one composition is unique to Japanese art. The ceaseless progression of nature, its evanescence and cyclic structure, are reflected in this form. The landscape in Japanese art thus conveys feeling, ideas, and creativity, making depictions of nature—landscapes—dioramas of unreality. While this means of representation was reaching a golden period in Japan during the fourteenth through sixteenth centuries, in Europe the rules of perspective drawing and the development of the sciences as reflected in the so-called objective and realistic depictions of nature in oil paintings were also gaining traction. These two distinct yet concurrent movements in art history make for a remarkable study in contrasts.

Monochromatic Expression

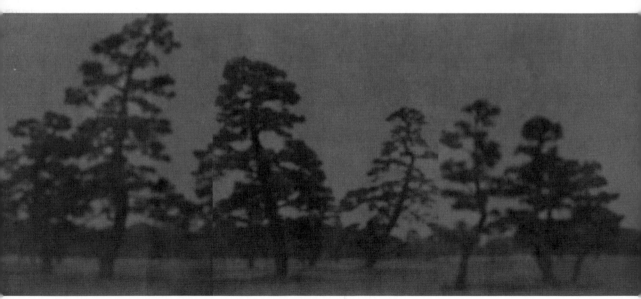

杉本博司《松林図》
Fig. 48: Hiroshi Sugimoto, "Pine Forest," 2001. Gelatin-silver print. Two six-paneled screens, each 716.2 × 49.2 cm.
© Hiroshi Sugimoto. Courtesy of Gallery Koyanagi.

長谷川等伯《松林図屏風》(国宝)

Fig. 47: Tōhaku Hasegawa, *Shōrin-zu byobu*, Azuchi-Momoyama Period. Designated National Treasure. Sumi ink on paper. Six panels, each 156.8 × 356 cm. Tokyo National Museum. Image: TNM Image Archives Source: http://TnmArchives.jp

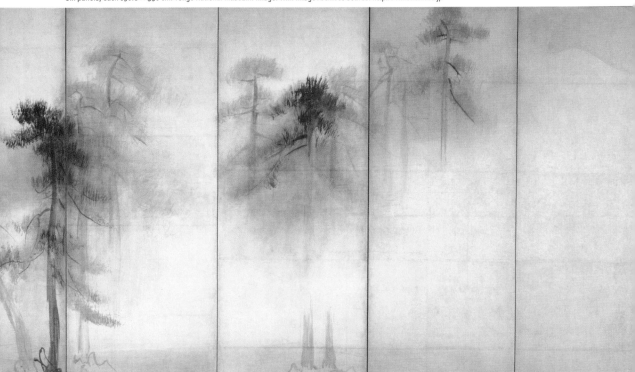

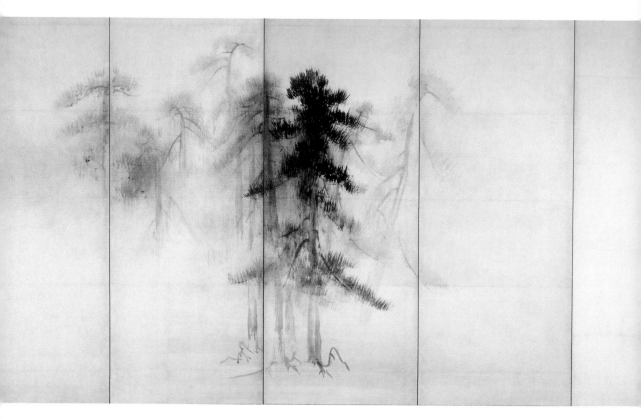

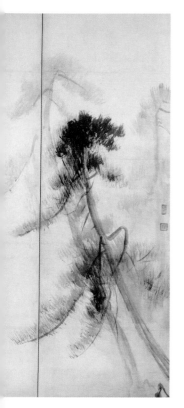

In the late sixteenth century, during the life of Tōhaku Hasegawa, the predominant style of painting was the lustrous Kanō school, of which Eitoku Kanō (fig. 4) was broadly recognized as a master. Hasegawa, on the other hand, was a court artist employed by the shogunate. He followed the major trends of the Azuchi-Momoyama period, as established by the Kanō school, and immediately before producing this monochromatic image of a pine grove (fig. 47), he was completing work on a heavily gold-embellished painting at the Chishaku-in Temple in Kyoto. Upon completion, he received news of the sudden death of his young son Kyūzō (fig. 54). He returned to his hometown of Noto (located on a peninsula off Japan's main island of Honshu in the Sea of Japan), and in his time of mourning he produced this subdued composition of pine trees. Influenced by thirteenth century Chinese ink-and-wash artist Mokkei (known in Chinese as Muqi Fachang) and Sen no Rikyū (fig. 24), who founded *wabi-cha*, Hasegawa learned the beauty of *wabi-sabi*—a mode of expression wholly different from the extravagance of gold leaf and ornamentation. Within a dense fog, wind thrashes about the trees, dispersing the pine grove's shadow. A harmony of monochrome reveals the depth and the desolation of the white space, which occupies a majority of the drawing plane. This balance is brimming with mystery and evokes a sense of life's evanescence. "In the evolution of expression that's limited to variations of shade produced by black ink, there is a commonality with the expression of the monochromatic photograph, which I have been researching," says Hiroshi Sugimoto, with allusions to Hasegawa's folding screen. Where Tōhaku renders a scene of transience with his ink marks devoid of color, Sugimoto pursues a timelessness (or time before human's invention of time) in his photographs (fig. 48).

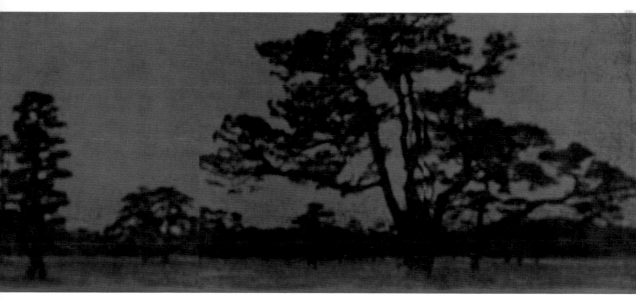

長谷川等伯 ＋ 杉本博司

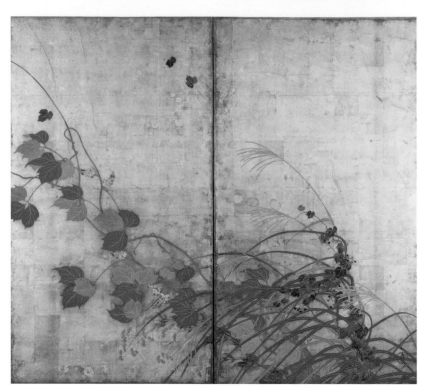

酒井抱一《夏秋草図屏風》(重文)

Fig. 49: Hōitsu Sakai, *Flowering Plants of Summer and Autumn*, 1821. Designated Important Cultural Property. Color on silver over paper. Two panels, each 166.9 × 184 cm. Tokyo National Museum. Image: TNM Image Archives Source: http://TnmArchives.jp

小瀬村真美《四季草花図》

Fig. 50: Mami Kosemura, *Flowering Plants of the Four Seasons*, 2004–06. Animation/installation, DVD 5-23 minutes (auto-looping), color, sound. Courtesy of Yuka Sasahara Gallery, Tokyo.

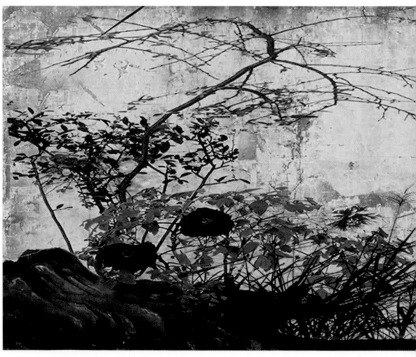

Nature Reconstructed

Mami Kosemura understands that simply drawing something in three dimensions does not reveal its "nature." Her image of grass and trees is in fact a collage of numerous photographs she took of a potted plant (fig. 50). In postproduction, she created a vegetation that does not otherwise exist. Form arises from this process of revision and accumulation—a contrivance through which it eventually embodies the life it was originally intended to copy. Kosemura adds another dimension to the work through animating it; a gentle breeze makes the grasses sway like leaves on a branch, showing the gradual passage of the four seasons. The accumulation of time in the video relates to the treatment of autumnal grass bent by strong winds and to summer grasses drenched by a sudden downpour in Hōitsu Sakai's *Flowering Plants of Summer and Autumn* (fig. 49). Hōitsu is known for reviving the legacy of the Rimpa school of painting (fig. 8), and we can see in the work of Rinpa a typical treatment of ornamental expression, which includes an aspect of verisimilitude in rendering nature.

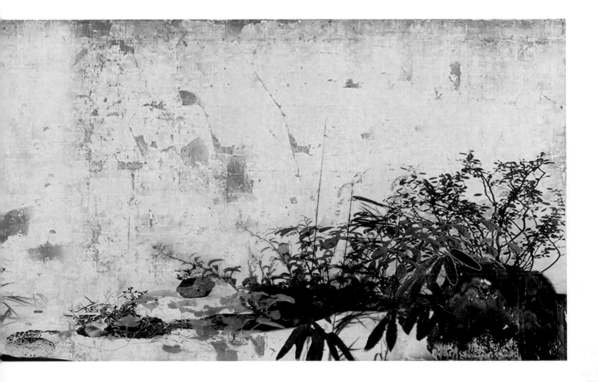

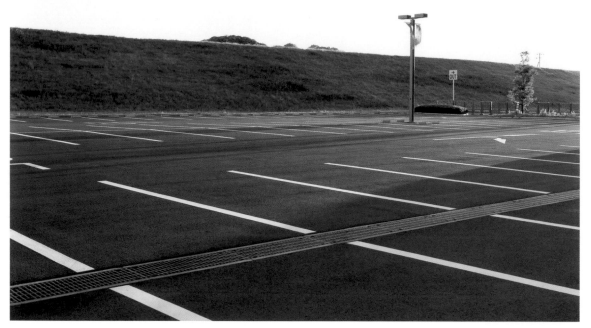

ホンマタカシ《Yokohama National Athletic Stadium》
Fig. 51: Takashi Homma, "Yokohama National Athletic Stadium," 1999. Cibachrome print. Collection of the artist.

俵屋宗達（賛：烏丸光広）《蔦の細道図屏風》（重文）
Fig. 52: Sōtatsu Tawaraya with calligraphy by Mitsuhiro Karasuma, *Narrow Road of Ivy Vines*, Edo period (17th century). Designated Important Cultural Property. Color and gold ground on paper support. Six-paneled screen, 159 × 361 cm (detail), Shōkoku Temple, Kyoto.

The Curiosity of Framing

Comprised of just two colors—gold and green—the edge of the field is cut as by a blade and offset with a deeply-colored vine leaf, which provides a rhythm to the picture (fig. 52). Sōtatsu Tawaraya's *Narrow Road of Ivy Vines* is based on the tale of the poet and aristocrat Ariwara no Narihira in *The Tales of Ise*, who journeyed east, away from Kyoto. The landscape is an extreme abstraction of the boundless mountains, suggesting the unease with which Narihira made his departure from the capital and the loneliness of the journey. But even if the order of the left and right sections is swapped, the shapes of the composition remain uninterrupted; the connectivity of the two panels gives the feeling of an endless, undistinguished mountain pass. In contemporary landscapes, the city, the countryside, and the suburbs have all undergone an extreme homogenization; no matter where you go, there is a monotony that extends interminably. Photographer Takashi Homma has captured that same feeling of meaninglessness in his suburban landscapes (fig. 51). Homma's peculiar framing of an empty parking lot is reminiscent of Sōtatsu's landscape compositions, expressing limitlessness within a confined area while also converting a landscape into an artificial diorama.

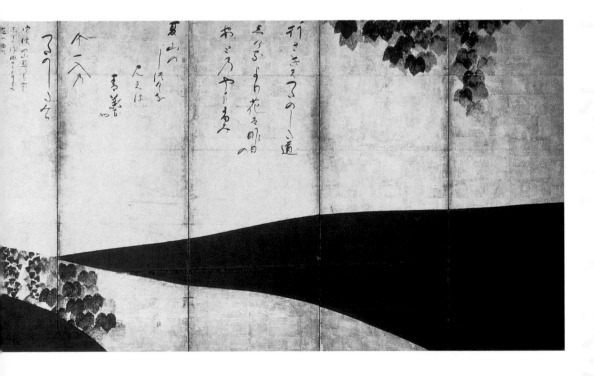

Mourning and the Tree of Life

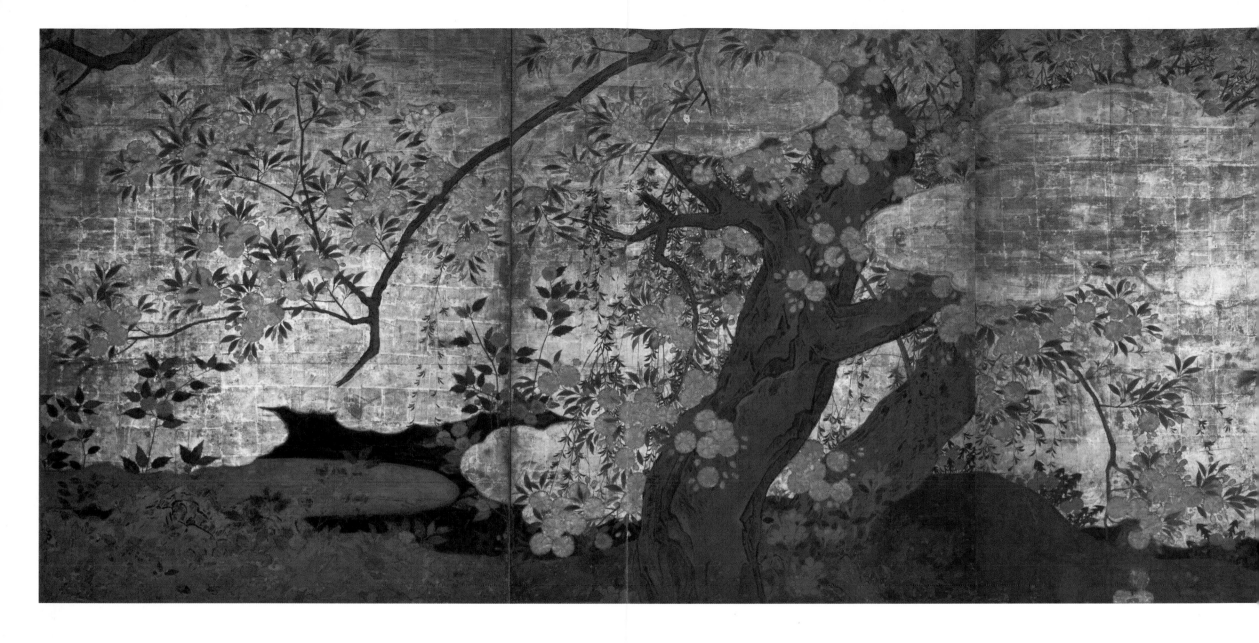

In a vein similar to the drawings on folding screens and sliding doors, Oscar Oiwa has created a large piece using several equal-sized canvas panels (fig. 53). Throughout the five sections of *Flower Garden,* which was commissioned by the Hiroshima City Museum of Contemporary Art, the composition is linked. Yet when the work was first exhibited, the middle panel, with a large tree in its center, was omitted. Like the unreal light that poured down upon the streets of Hiroshima moments before the detonation of the atomic bomb, this landscape similarly glows. With the addition of the center panel and the roots of the trees growing into the ground, however, the landscape becomes a symbol of hope for the regeneration and future of Hiroshima. The large tree, which serves as the life force of the picture itself, was a robust expression and a widely adopted motif in art of the Azuchi Momoyama period. During the reign of Nobunaga Oda and Hideyoshi Toyotomi, culture developed under the watchful eyes of the authorities. In this cultural climate the *Sakura-zu* of Kyūzō, the first-born son of Tōhaku Hasegawa (fig. 47), displays an exceptional elegance, surpassing his father's talents. This work (fig. 54) was made as a painting on sliding doors for Chishaku-in Temple, which was erected as a memorial for Hideyoshi's son Tsurumatsu, who died at a young age. The attenuated branches of the young *sakura* (cherry blossom) tree reach out, symbolizing unrealized dreams.

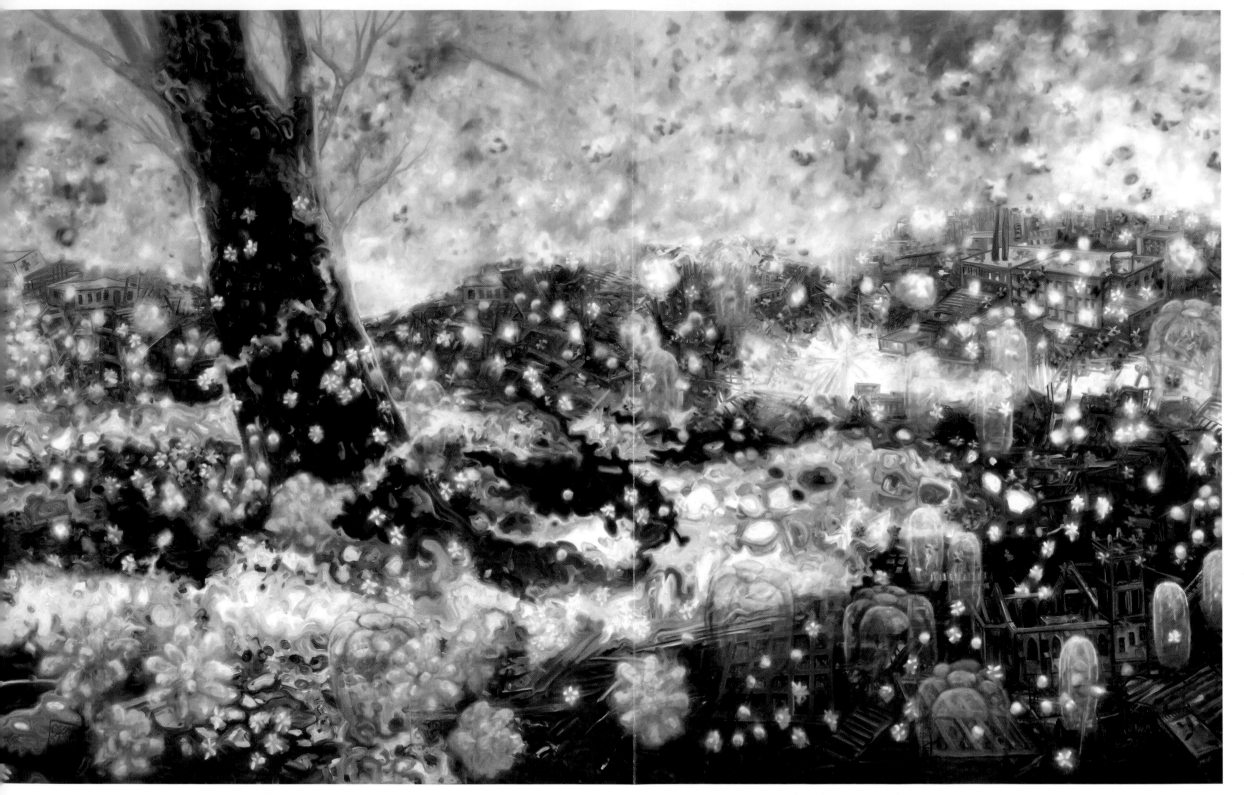

大岩オスカール《フラワーガーデン》
Fig. 53: Oscar Oiwa, *Flower Garden*, 2004. Oil on canvas. Five panels, 227 × 555 cm.
Hiroshima City Museum of Contemporary Art. Private Collection.

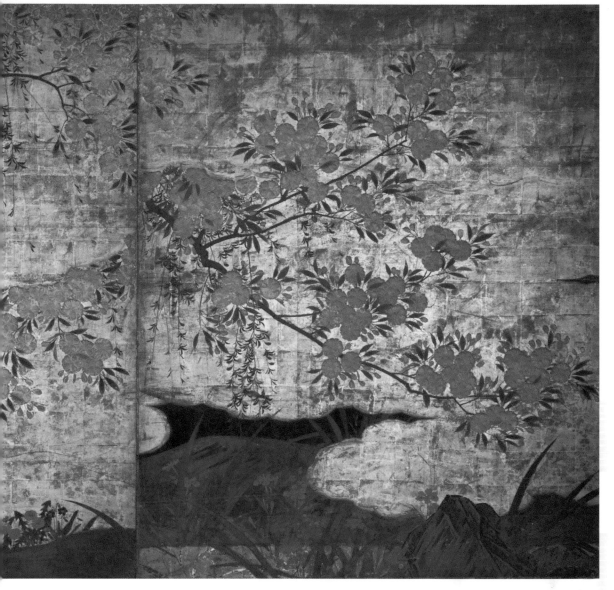

長谷川久蔵《桜図》(国宝)

Fig. 54: Kyūzō Hasegawa, *Sakura-zu* (Cheery Tree on Sliding Door), Momoyama period. Designated National Treasure. Color on gold. Four panels each 175.6 × 139.5 cm. Chishaku-in Temple, Kyoto.

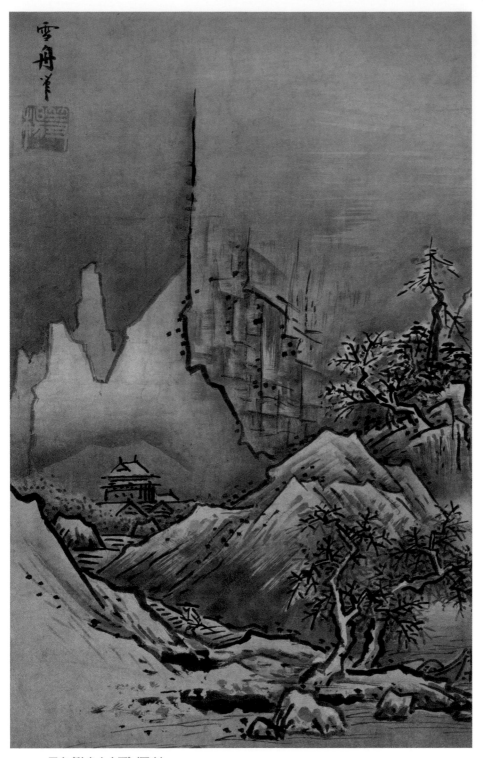

雪舟《秋冬山水図》(国宝)

Fig. 55: Sesshū, *Winter Landscape*, Muromachi period (15th century). Designated National Treasure. Sumi ink on paper. 46.3 × 29.3 cm. Tokyo National Museum. Image: TNM Image Archives Source: http://TnmArchives.jp

Shiro Ohtake commonly uses the word *kei* (diorama) in naming his series. The artist explains, "When I was young, I was gobsmacked to learn that with the placement of stone, greenery, and moss—natural elements—a landscape could be created with *bonkei* (a miniature landscape garden). Everything was condensed into this miniature landscape. The world outside of me and the world inside of me—all of it. For that reason, diorama not only means a landscape but also relates to an outlook on the universe." The *bonkei* to which Ohtake refers was a form originally created in China during the Tang Dynasty and brought to Japan, where it was appropriated as a three-dimensional version of *sansui-ga* (traditional paintings of hills and rivers). Later, *bonkei* developed into *bonsai* (dwarf potted trees). A landscape was not realistically copied on paper, rather the elements of nature were reassembled and remade. This was called *tenkaitoga*, meaning a nature landscape that is "opened" by God; the landscape does not serve to represent a naturally occurring landscape but rather in its reconstruction of the landscape it expresses the spirituality (the presence of God) in the landscape. Considered the progenitor of *sansui-ga*, Sesshū similarly incorporated an ethic of *shinga* (spirit drawing) wherein the artist bypasses the hand to draw with the mind/spirit. In Sesshū's brushwork, the scene recedes without interruption.

Ohtake uses a similar process of deconstructing elements of nature in his contemporary landscapes, which stand in stark opposition to the scenic beauty of *sansui*. Instead they are comprised of squalid streets cluttered with billboards, neon lights, rubbish, and drab building blocks layered with cheap printing or corrupted film that is visibly tainted with noise. The banality of the elements he uses to reconstruct "something that is already there" is in effect Ohtake's "nature." In this way, Ohtake's process can be seen as a continuation of the traditions of *tenkaitoga*.

大竹伸朗《東京―プエルト・リコ》

Fig. 56: Shinro Ohtake, *Tokyo–Puerto Rico*, 1986. Collage, gouache, pastel, printed matter (manga), wood frame. 198.5 × 194 cm. Private collection.

ANIMISM

(*tama*)

All Is Alive

In ancient times, Japanese people believed that all phenomena—all things in the universe—contained a god or spirit presence. This animism—perhaps the oldest aspect of the Japanese mentality—would later develop into nature worship and spirit worship. Animism is recognized throughout the world as the belief predating all religions. In Japan, however, it has a particular status: despite being a primitive form of religion it did not diminish with history; rather, it adapted to new religious systems that were adopted in Japan, and continues today. One example is Ise Shrine. Beneath the floor of the edifice, there lies buried an *onbashira* (an honored pillar or column) worshipped as a *yorishiro*, a physical space or place occupied by a god—usually a rock, tree, animal, or other such natural element. Japan's oldest shrine, Ōmiwa Shrine in Nara, is at the site of a mountain worshipped as a deity itself. Other examples include large trees or *iwakura* within the precincts of a temple shrine that are revered with ropes of sacred straw. Rather than destroying a preexisting system to allow for a newer one, old forms are absorbed and fused to make something new.

In this way, animism became a part of Shintō. After the advent of Buddhism, it connected with Buddhism to form Shugendō and Sangaku Shinkō, prompting religious art devoted to the worship of mountains or waterfalls as holy bodies. Esoteric Buddhism, Mappo Shisō, Pure Land Buddhism, and Maitreya Shinkō, and in recent times the introduction of Confucianism—animism connected with each belief or doctrine through the ages, changing shape in each instance, making it a constant presence in Japanese consciousness. Such a genealogy of animism is not limited to belief systems or religious art; it appears in close association with manners, customs, and culture. Osamu Tezuka said with passion regarding anime production, "When the inanimate picture begins to move, the picture has life. Anime breathes life into pictures." The etymology of the word "animation" itself has to do with spirits, soul, life: *anima*.

《富士参詣曼荼羅》（重文）

Fig. 57: *Fuji Sankei Mandara*, ascribed to Motonobu Kanō, Mid-16th C. Designated Important Cultural Property. 186.6 × 118.2 cm. Color on silk. Fujisan Hongu Sengen Shrine, Shizuoka Prefecture.

鴻池朋子《隠れマウンテン―襖絵》(部分)
Fig. 58: Tomoko Kōnoike, *Hidden Mountain—Fusuma Painting*, 2008. Mixed media. 182 × 544 cm.
Courtesy of the artist and Mizuma Art Gallery.

In one of Japan's primitive religions, Sangaku Shinkō, it was believed that gods and spirits descended into mountains to dwell. Mountains also served as burial grounds, as they were revered as a place to which spirits of the dead would return. Mountains were treated as hallowed ground that was the dividing line between this world and the next. Mountain sects of Sangaku Shinkō were established by Buddhist priests of the early ninth century—one on Mt. Kōya by Kūkai and another by Saichō on Mt. Hiei (near Kyoto). Mt. Fuji—the island nation's tallest mountain—holds a special status among them all. In a famous collection of poems, *Manyōshū*, from the eighth century Nara period, Mt. Fuji is described as a holy guardian of Japan. The belief in Mt. Fuji spread among the common folk from the last years of Japan's medieval period to the Edo period, and climbing Mt. Fuji was popular among the faithful as a form of religious retreat, as exhibited in *Fuji Sankei Mandara* (fig. 57).

In Tomoko Kōnoike's *Hidden Mountain* (fig. 58), there is an apparent connection with Sangaku Shinkō. "I am interested in the boundary that connects two worlds," says Kōnoike, who often uses sliding doors as the support for her paintings, since these are an "entrance to another world." In drawing a face on the mountain, the mystical world that is hidden on the other side is seemingly within the forehead—in one's own mind. On the back of the sliding door is drawn a hypertrophied brain floating in outer space. When this work was first exhibited, it was installed at the top of a commercial building, which served as a metaphor for a mountain. As part of the viewing experience, gallery visitors were discouraged from using the building's elevator and asked to climb the stairs, as if making a pilgrimage.

富士山 ＋ 鴻池朋子

99 ANIMISM

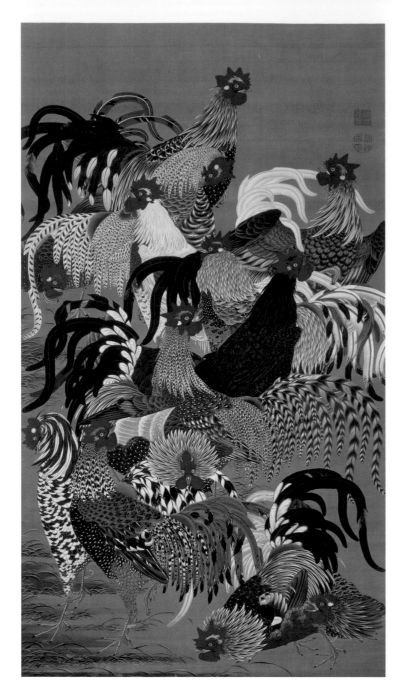

伊藤若冲《動植綵絵 群鶏図》
Fig. 59: Jakuchū Itō, *Colorful Realm of Living Being, Fowls*, 1755 (Edo period). Hanging scroll; color on silk. 142.6 × 79.7 cm. The Museum of the Imperial Collections, Sannomaru Shōzōkan.

Among the Japanese artists who have produced beautiful specimens of *kachō-fūgetsu* painting, Jakuchū Itō's work is a world apart. *Kachō-fūgetsu* is a thematic genre. The word is a compound of the characters for "flower," "bird," "wind," and "moon," and the subject of such paintings is the appreciation of nature's splendor. The psychological depth of this piece is on par with works of surrealism. Through the sensitivity and technique of his renderings of nature, Jakuchū was able to express something extraordinarily: the force of nature's strength and the spirits hidden inside. The character of his style can be described with three key terms: figure, geometric composition, and proliferation. In *Colorful Realm of Living Being, Fowls*, the chickens' features are drawn accurately; the painting diverts from a realistic image, however, and leaves a bizarre impression, strewn throughout with countless eyes. Multiple patterns and recurring structures create a grid-like, optical composition.

Such vivid depiction of proliferation is also found in the work of contemporary artist Yayoi Kusama (fig. 60). She is known for her painting series Infinity Nets, as well as her extensive use of motifs such as dots and soft-sculpture penises, with which she fills the visual field in a compulsive, nervous way. The dots that Kusama has drawn are equivalent, in this manner, to the unconscious eyes of Jakuchū. A ladder, a sofa set in a living room—interior furniture, even if inorganic, is not viewed as such by Kusama. She was raised in Nagano Prefecture, a verdant region of Japan, and in her childhood she often spoke with trees, and at times with flowers. For Kusama everything in the universe is full of life that has developed and multiplied. Kusama's world extends back to the ancient times of Japan, namely Pure Land Buddhism and its naturalist view of the universe.

草間彌生《Traveling Life》

Fig. 60: Yayoi Kusama, *Traveling Life*, 1964. Mixed media. 248 × 82 × 151 cm.
© Yayoi Kusama. National Museum of Modern Art, Kyoto.

田中圭介《回天》
Fig. 61: Keisuke Tanaka, *Kaiten*, 2008, Acrylic on camphor tree, lead, natural pigment. 270 × 260 × 257 cm. Photograph by Keizō Kioku. Courtesy of YAMAMOTO GENDAI, Tokyo.

《大楠》
Fig. 62: Large camphor tree, approximately 2,000 years old. 20 × 20 m.
Kinomiya Temple, Shizuoka Prefecture.

The Mysticism of Forests

Those born in villages located in thickly grown forests often considered the forest a deity and worshipped the woods as the controllers of destinies. Common Japanese surnames such as Tanaka (meaning "surrounded by a field") and Suzuki ("a bell tree") are also connected with forests. The Kinomiya Shine in Atami (about an hour south of Tokyo) has a sacred tree more than two thousand years old (fig. 62). Since the Meiji period (1868–1912), which brought the mixing of Buddhism, Shintoism, and urban development, forest societies collapsed, leaving little trace. The history of woodcraft in Japan is said to be contemporaneous with the introduction of Buddhism in the sixth century, and is understandably connected with spirituality. Using such a sacred wood as the material for his sculpture, contemporary woodcrafter Keisuke Tanaka makes plain reference to the holy reverence paid to trees from ancient times (fig. 61). A small shrine made from carved wood serves as a signpost for a forest where spirits are believed to dwell. The billowing cloud massing above the forest also exhibits the mystic essence of trees and forests. It shows a contemporary version of nature worship.

Architecture at One with Heaven

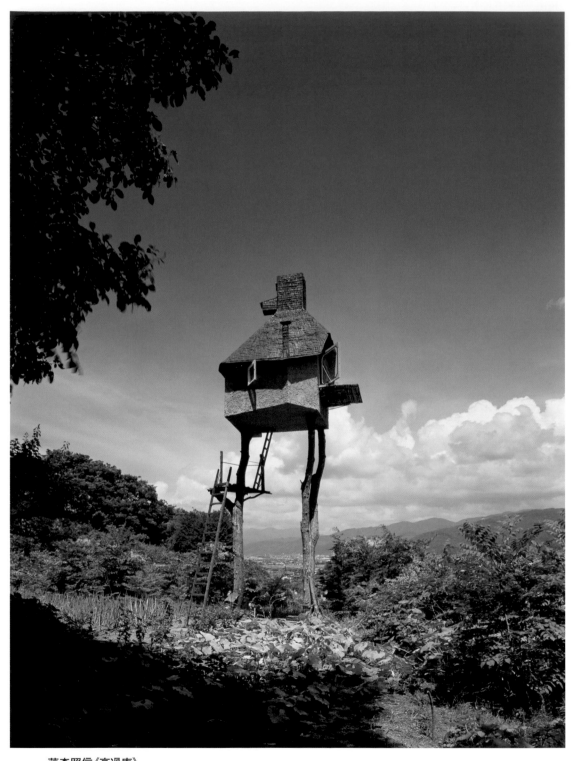

藤森照信《高過庵》

Fig. 63: Terunobu Fujimori, *Takasugi-an*, 2003–04. Tea house; wood frame, stucco, copperplate roof. Nagano Prefecture.
Photography: Kisei Kobayashi.

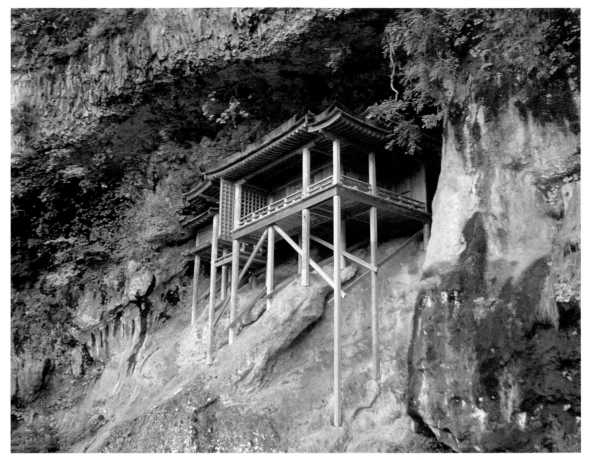

《投入堂》（国宝）
Fig. 64: *Nageire-dō*, 849 (Heian period). Designated National Treasure. Wood frame.
Mt. Mitokusan, Tottori Prefecture.

This ninth-century temple is believed to be highly responsive to prayers, and according to local lore was created by a priest using the power of Buddhist dharma to throw the temple into a crevice on the side of a steep cliff (fig. 64). Hence, Sanbutsu-ji temple came to be known as the Nageire-dō (thrown-in temple). In this place the ancient Japanese faith of Sangaku Shinkō was combined with Buddhism to form Shugendō—a faith based on development of spiritual strength through unity with nature. In addition to the gentle eddies of the roof, which is a *hiwadabuki* (a roof covered with layers of Japanese cypress *hinoki* tree bark shingles), the columns are of varying length. Even within the varieties of Japanese temple architecture, this is a rare and magnificent construction. Architect and historian Terunobu Fujimori references Nageire-dō as the origin of modern Japanese architecture. The primitivism and astounding elevation of his own construction, a private tea ceremony room called Takasugi-an (fig. 63), exhibits influences of the ninth-century temple. Balanced on two chestnut trees, this quaint tea house—located in the back garden of the home in which Fujimori was raised—was built without the aid of a detailed architectural blueprint. Its two support columns are living trees, which are in turn significant for their regional historical import. The place of the architect's home, Suwa (in Nagano prefecture), is in an area that was once called Mishakuji, meaning "faith in a native god." Suwa's large temple holds commemorative ceremonies to honor the columns of its structure, because it is believed that gods descend to earth through these vessels. Similarly, it also is believed to provide ascension to heaven.

《御嶽》

Fig. 65: Hallowed ground on the main island of Okinawa. Photography by Naoki Ishikawa, 2005.

A Return to the Earth

On Naoshima, one of the remote islands of the Seto Inland Sea, in a work entitled *Being Given* (fig. 66), Rei Naito has recreated a fisherman's folk tradition that has existed since the Edo period. Limited to a single viewer at a time, who can spend no more than fifteen minutes there, the work is entered from a small side door (one must duck one's head to enter), with only a sliver of light through the small opening that runs along the perimeter. The light reflects off beads, threads, and tiny pearl-like stones—elements of construction of a Shintō precinct. In the execution of this project, the building's roof, columns, and outer walls were maintained, while everything else was removed, including the floor. In doing so, the "raw earth" that was untouched by light and air was made bare. "The earth is the first precondition for human existence. Touching this soil returns us to the start of everything," says Naito. "Earth supports all life and is the place to which the dead return." In the center of the construction there is a large marble disc, representing the time of heaven—a circularity without beginning or end. In particular, the large stone is revered as a place of purity to which the gods descend. Naito's *Being Given* summons the divinity that was originally contained by earth, light, and stone, harking back to a time in the island nation's past before it was a nation, before Shintoism, before religion took form, to the prehistory of spirituality. After the passage of thousands of years, this spirituality lives on in this work. The rock formation shown in figure 65 is believed to be sacred and is one of many nature sites revered through Japan's history.

内藤礼《このことを／家プロジェクト　きんざ》
Fig. 66: Rei Naito, *Being Given (Naoshima, Home Project Kinza)*, 2001. Earth, wood, stone, glass, bamboo, tile, mirror, thread, beads, stainless steel, aluminum, plastic, shell. Lot 197.71 sq. m., building 53.49 sq. m. Benesse Art Site, Naoshima

The Ghostly in the Complete Harmony of Man and Nature

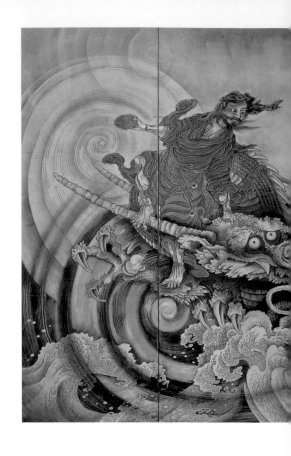

曾我蕭白《群仙図屏風》(重文)
Fig. 67: Shōhaku Soga, *Gunsen Byōbu* (Assembly of Immortals), 1764 (Edo period). Designated Important Cultural Property. Color on paper. Two sets of six-panel screens, each 172 × 378 cm.

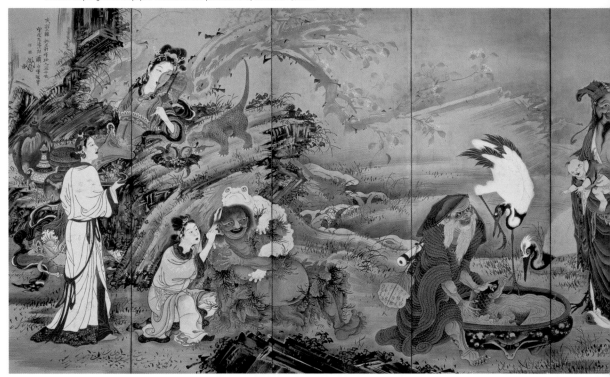

Shōhaku Soga's name came into prominence within the canon of Japanese art history with the discovery of *Gunsen Byōbu* (Assembly of Immortals; fig. 67). The style, expression, composition, and deployment of color are without parallel. These ghostly figures are drawn with ink and wash in a naturalistic landscape, but upon closer inspection the plants seem to be an extension of the Immortal's flesh, drawn like a code, indicating that within this composition man and nature know no division, setting into motion the total harmony of the painting's overall dynamism.

In a similar vein, Etsuko Fukaya's *Untitled* (fig. 68) is not an assembly of individual entities but presents one contiguous being unto its own. Within a small universe, the ordinary is drawn out with detailed lines, giving a sense of the restless movement of fauna. The artist's choice of subject represents a state of being devoid of self-awareness and the impulses derived from such. Rather, the attention to detail in the elements of her renderings communicate the experience of aliveness particularly within an extremely small world.

冨谷悦子《Untitled》
Fig. 68: Etsuko Fukaya, Untitled, 16.0 × 40.0 cm. Below: detail view. Copperplate Print.
Courtesy of YAMAMOTO GENDAI, Tokyo.

The Kneaded Surface of the Soul's Skin

西尾康之《トランスフォーム―変態―1》
Fig. 69: Yasuyuki Nishio, *Transform #1*, 2004. Negative cast, fiber plaster. 143 × 132 × 40 cm. Photo by Keizō Kioku. Courtesy of YAMAMOTO GENDAI, Tokyo.

《火焔型土器》(国宝)

Fig. 70: Flame-shaped earthenware, Middle Jōmon period (3000–2000 BCE). Designated National Treasure. 34.5 × 33.6 cm. Unearthed at the Sasayama mountain of Niigata Prefecture. Tokamachi Municipal Museum, Niigata Prefecture.

縄文土器 十 西尾康之

Sculptor Yasuyuki Nishio uses his own unique relief-casting method (fig. 69). Sculptors usually work from the outside in—building form—but Nishio works from the inside out. The kneaded clay is molded piece by piece by the artist's fingertips, giving the outer layer countless fingerprints. In using this technique, the artist's own self is enveloped within the sculpture and Nishio believes the resulting exterior thereby becomes the "soul's skin"—which is certainly far from smooth.

In a similar way, earthenware sculpture from Japan's Jōmon period (14,000 BCE to 400 BCE; fig. 70) has a "shape of the spirit" quality. A simple chalice, in this instance, is rendered with what seems to contemporary eyes to be extreme ornamentation. Yet it is its holy deportment that serves as the overwhelming defining character of the sculpture. The people of these early times believed the spirit of a powerful magic was transferred to the craftsman's fingertips, which in turn gave the earthenware its form.

束芋《hanabi-ra》
Fig. 71: Tabaimo, *Hanabi-ra*, 2003. Frame from video installation, approx. 4'24". ©Tabaimo. Courtesy of Gallery Koyanagi, Tokyo.

Tabaimo:
A Tradition of Play

In Tabaimo's work there is a profusion of Japanese codes to be deciphered—the Japanese salaryman, housewife, high school girl, OL (office lady), *yakuza* gangster, and *sumo* wrestler all feature prominently. Settings include the inside of commuter trains, bustling crosswalks, public baths, public toilets, and kitchens of family homes— all ordinary scenes of daily life in Japan. Iconic images such as Mt. Fuji, the royal chrysanthemum, and the red circle of the Japanese flag also appear. Her animation technique incorporates traditional methods of Japanese painting: in contrast to the uniform lines of *manga*, Tabaimo draws each cell with a brush pen, echoing the brush strokes of traditional *sumi-e* (ink on paper). Drawn in one ink color, the images are then scanned and converted to data. Then she begins the process of applying color digitally. Her palette is an abstraction of the colors used in the *ukiyo-e* of Hiroshige Utagawa (fig. 13) and Katsushika Hokusai (fig. 77), and a borrowing from the slightly faded tones of silk paintings. Tabaimo's work satirizes the social ills of contemporary times, and for this reason her work is referred to as "Moving Ukiyo Zōshi" (Moving "Floating World" Sliding Doors).

The connection between Tabaimo's art and traditional Japanese work is not merely due to formal links. Throughout her work there is a conceptual current that is fundamentally Japanese, relating specifically to ideas of life and death. The prickly and at times grizzly elements of Tabaimo's work are an extension of this: a young woman stuffed into a bag; the dissection of a frog's innards; a man removing his flesh as if stepping out of a costume; or a business man chopped up in a kitchen. No specific references are required—the view of life and death in the Edo period (seventeenth to eighteenth century) is clearly a conceptual underpinning.

The human fear of death is universal, and can be seen as the basic driving motivation behind cultures, religions, philosophies, and art around the world. But ways of dealing with this problem—attempts to overcome the fear of death—differ greatly by culture and civilization. Variations in the perception of life and death gave rise to different religions, which in turn created differences of expression in religious art, influencing thought and rituals of daily life.

In Japan there is a particular philosophy, religious thought, and culture around death. Tabaimo reflects these tendencies, which can be termed a *ukiyo* view of life and death. *Ukiyo*, or floating world, is a concept that spread in Japan's Edo period, when the country was unified under the isolationist control of the Tokugawa shogunate, and had minimal dealings with foreign nations. The term was originally written with a different character, which refers to pain or hardship, expressing a lament for the fleeting evanescence of life. From the Edo period this *ukiyo* led to hedonism and nihilism, thereby shifting the negative connotation of *ukiyo* to more earthly, pleasurable associations. This novel sense of *ukiyo* was not without precedent in the Edo period. Rather, it was a new term for an ancient concept previously described as *okashi* (which means "funny" in contemporary Japanese).

In *Nihonbijutsu no Mikata* (*Looking at Japanese Art*), art historian Nobuo Tsuji states that the continuation of *okashi* from generation to generation is an expression of an innately Japanese spirit of play. This spirit is present as far back as the Jōmon period (eleventh century BCE to fourth century CE). Beginning with Jōmon earthenware, the graffiti-like writings of the Tenpyō period (eighth century CE), and the abolishment of the dynastic nobility by the envoy to the Tang clan in the Heian period (eighth to twelfth century CE), the spirit of play in ornamentation is abundant. From the end of the ninth century, the nobility started to enjoy *giga*, illustrations intended as entertainment in the form of visual games or puzzles. (The first character of *giga* 戯画 is the same character that titles chapter 6 of this book—*tawake*.) The eleventh-century anthology of ancient writings, *Konjaku Monogatari*, included *oko* (humorous drawings). Tsuji

束芋

束芋《dolefullhouse》

Fig. 72: Tabaimo, "Dolefullhouse," 2007. Still from video installation, 6'. © Tabaimo.
Courtesy of Gallery Koyanagi, Tokyo.

explains that *oko* denotes something foolish or stupid, but with no inference of disdain; rather, it is a form of flattery. This artistic form also helped awaken a facility for imagination, as it was a complicated mixture of language and image. Such imagination is evident in works of the twelfth century including: *Chōjū-giga* (Scrolls of Frolicking Animals), the *Shigisan-engi* (Legend of Mount Shigi), scroll painting, and *Jigoku-zōshi* (Handscrolls of Buddhist Hell). These pieces were replete with wit, while story development and the introduction of characters (portrayed as animals) was archly satiric. For Tsuji, modern day manga and anime can be seen to have inherited the legacy of this culture.

During the isolationist Edo period, a new social class emerged: the merchant class, akin to the European bourgeoisie. Despite having some economic status, they were considered to be of the lowest class—yet the development of culture fell to these townsfolk, who infused playfulness and humor and produced *ukiyo-e* conveying views on life and death.

From the ninth to the twelfth centuries, with the country isolated from the rest of the world, dynastic families were responsible for the commissioning of artwork and the sponsoring of artists and craftsmen to create painting, design, and architecture. In the last days of the shogunate era, when the country was opening up to exchange with outside nations and eager to absorb aspects of foreign contemporary civilizations, Japan

束芋《ギニョる》

Fig. 73: Tabaimo, "Ginyoru," 2005. Still from video installation at Aros Sarhus Kunsemuseum, approx. 5'45". Photograph by Ufer! Art Documentary. © Tabaimo. Courtesy of Gallery Koyanagi, Tokyo.

began to adopt Western artistic practices, a process that is generally thought of as the end of a particular Japanese sensibility of humor. As previously noted, however, the flourishing manga and anime culture is one remaining legacy.

In Tabaimo's recent work, the expression of nuance and complete scenes has diminished, and instead a common concern now seems to be hands, skin, organs, hair—the body in parts. The nature of her animation has migrated from the incorporation of narrative or dramatic tension to one of momentary reflection. The progression of time, sequence, and causality present in her earlier pieces has faded to an animation that operates in essentially "no time." Tabaimo has turned her attention to basic themes, such as life or death, dealing with them as abstract problems. In this way, in her continuation of the traditions of Japanese art through playful yet disturbing animations, Tabaimo reveals the tenuous uncertainty of daily life, as mass popular culture continues its inexorable spread.

束芋

第6章

戯

JEST

(*tawake*)

Lighthearted, Serious Minded

Alongside the solemnity or reserve typically associated with traditional Japanese arts and crafts, there is also a robust playfulness and curiosity in the magnanimous depictions of entertainment, eroticism, sex, and celebrity. We can see this dating back to specimens of Jōmon-period clay figures embellished with playful figures—smiling and cheerful—or the Heian-period caricatures or scrolls depicting people as animals making comical movements and exaggerated expressions. Even *suiboku-ga* (drawing in India ink)—a medium characterized by the austerity of brush strokes on the sheet—can at first glance seem quite earnest, but it is clear that the brush strokes are like movements of a dance across the paper's surface. The macho realm of warriors was not immune: armor and other battle vestments were commonly adorned with witty features as seen in figure 37. In this manner, the spirit of play is linked with aesthetics, the apex of which spanned from the last days of the Momoyama period to the Edo period, when the helms of the arts transferred from those in power to those of common birth. In Japan's feudal system, society was organized into four distinct social classes—warriors, farmers, craftsmen, and, on the bottom rung, merchants. For this lowest tier, the popularization of art meant jest and wit, and at times games involving an arch sense of irony, all of which allowed for some reprieve from the challenges of everyday life. In Western art, especially in the context of fine art, "play" is seen as something crass or profane, leaving a decidedly negative impression. In Japanese art, however, "play" is the basis for life—an affirmation. Clearly this rich tradition of play lives on today in the flourishing worlds of anime and manga.

The Circus and Counterculturalism

In the Edo period, one of the most popular forms of entertainment for common folk was *suguroku*, a form of backgammon in which the boards are based on themes ranging from historical topics, tourism, popular novels, beautiful women, or kabuki. From the mid-Edo period onwards, the *suguroku* boards were printed in multi-color and each cell was filled with a large volume of information, integrated pictures and letters into an tightly organized composition (fig. 75).

This atmosphere is also apparent in the graphic design work of Tadanori Yokoo (fig. 74), who drew this poster *Koshimaki no Osen Circus* for the Jōkyō Theater, a 1960s theater troupe whose main star and impresario was Jūro Kara. The garish use of color, the cut-and-paste treatment of the collage, and the psychedelic and hectic conflation of elements has a garrulous quality. The Jōkyō Theater and Shūji Terayama's troupe Tenjō Sajiki were part of an underground theater movement that was active in the social and political upheaval of the 1960s. Appropriating a European theatrical style as anti-theory to the "new theater" of logocentrism (which favored speech over the written word), they carried out guerilla-style, wild performances that were aimed at the restoration of civil liberties and advocated the revival of Japan's native culture. Yokoo's graphic resembles *ukiyo-e* woodblock prints, while at the same time being anti-West and anti-contemporary, expressing a resonance with underground activities, political dissidents, and social rebellion.

横尾忠則《腰巻お仙 劇団状況劇場》

Fig. 74: Tadanori Yokoo, *Koshimaki-Osen Circus*, 1966. Silkscreen on paper. 103 × 72.8 cm. The National Museum of Art, Osaka.

《絵双六》（左：立斎広重『大日本物産双録』、右：一鶯斎国周『山門豪快双録』）

Fig. 75: Above: Unattributed artist, 1878, 61 × 73 cm. Tokyo Gakugei University Suguroku Collection.
Opposite: Unattributed artist, 1865, 107 × 90 cm. Tokyo Gakugei University Suguroku Collection.

仲條正義《沖ツ白波》
Fig. 76: Masayoshi Nakajō, *Oki-tsu-shira-nami* (White-crested Waves of the Open Sea), 2001.
Japan Graphic Designers Association Exhibition poster. Silkscreen on paper.

In *fin de siècle* Europe, solid swatches of color and discreet outlines presented a new design style that was bold as it was popular. The scope of Japonisme was apparent in the secessionist paintings of Gustav Klimt (in his use of intricate gilt patterning), as well as in France's long-established brand Louis Vuitton, whose brown-checkered signature line, Damier, took its inspiration from the popular Edo period Kabuki actor's clothing pattern recognized as "Ichimatsu Moyō." Vuitton's monogram was also inspired by the *kamon* (family crest). The appeal of Japanese design lay in its extreme simplification, coupled with symbolic deformation. This reduction of elements is a particular characteristic of Japanese graphic design. On the back of the *Jinbaori* coat shown here (fig. 78), the image shows a golden yellow Mt. Fuji in the darkness of night, emerging from the clouds; its peak is aflame with the whirl of a sacred fire. For Europeans, the contrast of colors, composition, and volume were novel and demonstrated an extreme sophistication.

Masayoshi Nakajō has inherited this legacy. A graphic designer for the cosmetics brand Shiseidō, with an extensive portfolio of corporate identities and logos, Nakajō makes full use of this combination of symbolization and simplification, creating graphic design that has the ability to communicate an identifiable message in a flash. With *Fuji No Yamai* (fig. 79), Nakajō uses an extremely simplified form to recreate an icon of woodblock printing. In figure 76, the complex net of waves and movements of Hokusai's *Kanagawa Okinami-ura* (fig. 77) have been simplified into a plain graphic, treating the dynamic crest of the large wave with one continuous, elegant stroke.

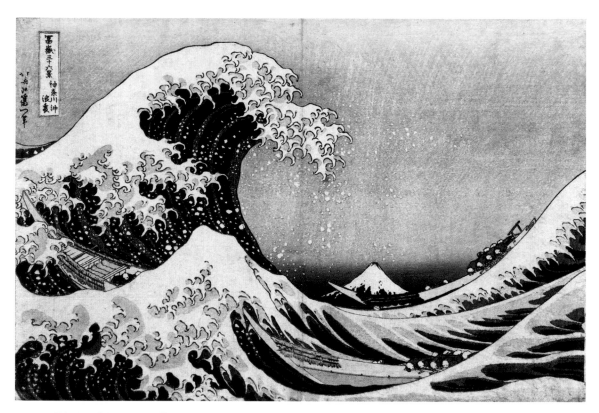

葛飾北斎《神奈川沖浪浦》
Fig. 77: Hokusai Katsushika, *Kanagawa Okinami-ura* (Great Wave Off Kanagawa), 1830–31 (Edo period). 25.5 × 38.2 cm. Keio University.

《黒黄羅紗地御神火模様陣羽織》

Fig. 78: Surcoat bearing design of Mt. Fuji and Divine Fire, early 17th century (Edo period). Wool. 97.8 × 52 cm. Osaka Castle.

Hgt. 3,776m
Vol. 1,400km³
Wgt. 100,000,000,000t
Lgth. E to W 28km, N to S 38km
Age 20,000 y.o.
Av. Temp. -6.8°C

仲條正義《フジのヤマイ》（2点）
Fig. 79: Masayoshi Nakajō, *Fuji No Yamai*, 2002. Silkscreen.

陣羽織＋仲條正義

Life and Death of the Animated *Ukiyo-e*

束芋《真夜中の海》
Fig. 80: Tabaimo, *The Sea at Night*, 2006. Video installation at the Hara Museum of Contemporary Art, Tokyo.
4'42". Courtesy of Gallery Koyanagi.

葛飾北斎《阿波の鳴戸》(『北斎漫画』第7篇より)

Fig. 81: Hokusai Katsushika, *Awa No Naruto* (The Rushing Strait at High Tide at Awa), 1814 (Edo period), from the seventh volume of *Hokusai Manga* (the complete works of Hokusai in fifteen volumes, published between 1814 and 1878). Color on paper, about 19 × 26 cm. Uragami Sōkyu-do, Tokyo.

Hokusai Manga assembles four thousand sketches by Hokusai Katsushika in fifteen volumes (fig. 81). The broad repertoire includes animals, plants, manners and customs, naturalism and spirits—so vast is the scope of his attention, depicting every natural (and otherwise) phenomenon, he was referred to as *ga-kyo-jin* (crazy drawing man). Capturing everyday life with persuasiveness and mastery of expression, Hokusai moved fluidly from one drawing style to the next, absorbing every established theme and technique in his path, from *Yamato-e* and *Rimpa* to Western painting styles. Within his seventy years there was little if anything that escaped his experimentation, but it wasn't until Tabaimo (see pages 116–119) that his illustration made the leap to animation (fig. 80). In contrast to the homogenous outlines typical of anime and manga, Tabaimo uses a pen to draw fluidly, and the hand-drawn feel of her lines evokes the movement of the brush. In her continual choice of death as a theme, and by using animation that converts the actual into the virtual, Tabaimo shows us the shift from pessimistic lament to floating world. Such virtuosity makes Tabaimo a contemporary *ukiyo-e* artist.

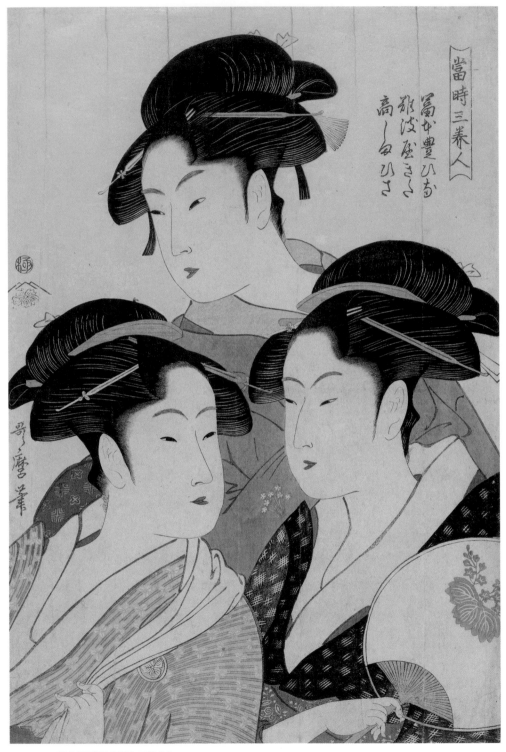

喜多川歌麿《寛政三美人》
Fig. 82: Kitagawa Utamaro, *Three Beauties of the Present Day*, c. 1793 (Edo period). Color on silk. About 39 × 26.5 cm.
William S. and John T. Spaulding Collection, 1921 21.6382. Photograph © 2010 Museum of Fine Arts, Boston.

Among the most popular artists of the Edo period *ukiyo-e*, Kitagawa Utamaro published pictures of beautiful people in a manner not dissimilar from contemporary posters of pin-up *aidoru* (idols, meaning pop-stars in this context; fig. 82). In Utamaro's careful hands, each and every strand of hair was drawn with utmost care, with delicate and graceful lines; there was a realism to his renderings that appealed to consumers. Rather than draw historical figures or beauties that are wholly removed from the real world, he chose to draw figures from everyday life—prostitutes, courtesans, or even the girl in the tea house next door. For the common folk, the figures who populated Utamaro's worlds were possibly people they could themselves come into contact with.

In modern times, photographer Kishin Shinoyama facilitates the same function in mass media. During the golden period of Japan's magazine world—a commercial and creative heyday of the 1970s and 1980s—Shinoyama's photographs were featured on countless magazines covers (fig. 83), but Shinoyama was not photographing stars. His influence was so significant that he was able to create idols through his camera. In his photographs of average women as models in pinup poses, which he called *gekisha* (meaning dramatic photo), he brought a zing of libidinal energy to the portrayal of ordinary women. His *gekisha* quickly became a social phenomenon, and the technique was emulated by photographers and magazines throughout Japan.

篠山紀信《「明星」の表紙》
Fig. 83: Kishin Shinoyama, November 1975 issue of monthly magazine *Myōjō* (Star), published by Shūeisha.

鈴木春信《お仙》

Fig. 84: Harunobu Suzuki, *Osen*, 1770 (Edo period). 20 × 28 cm. Sumishō, Tokyo.

The *bijin* (beautiful women) of Harunobu Suzuki's prints have a particular character—
fair-skinned, oval faced, with a hook-shaped nose and a fair complexion of girlish
innocence (fig. 84). Harunobu's *bijin* pictures were so popular that when he used a
server from a small tea house inside the precincts of a temple as a model, the number
of worshippers to that temple soared. He was able to draw images so rich with life that
one could almost hear the hushed conversation of two lovers depicted in *Osen*. He was
careful to include small touches, such as baubles, flowers, or a napping cat, flooding
an image with playful embellishments, each of which had significance (cf. *mitate*;
page 21). Similarly, Araki's photograph of a girl is an example of a *mitate* photograph
(fig. 85). The model's expression and pose, the richly colored, dark red curtain in
the background, the unfurled bellyband, the retro call-girl poster, the disarray of
the floor—all elements have been calculated to create an erotic charge and imply a
narrative. A toy elephant appears close to the model's feet, with its upturned trunk
held aloft in excitement—perhaps as a play on the cat of Harunobu's scene.

The Iconography of Erotica

葛飾北斎《喜能会之故真通》

Fig. 86: Hokusai Katsushika, *Taco To Ama* (Octopus and Shell Diver), illustration for the novel *Kinoenokomatu*, about 1820 (Edo period). Uragami Sokyu-do, Tokyo.

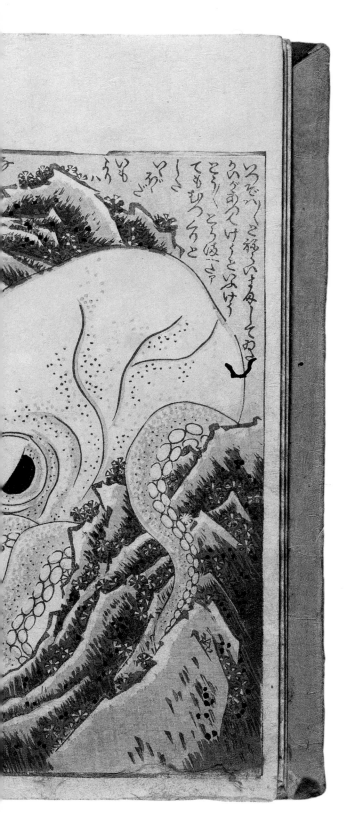

Pop Culturalism and Desire

Bijin-ga (pictures of beautiful women; page 134), *yakusha-e* (actor portraits; fig. 82), or the scandalous *shunga*—erotic prints—were the main varieties of *ukiyo-e* prints produced, highlighting the public's desires. *Shunga* fetched high prices in a hidden trade, and were kept from public view. To please the tastes of collectors, they were printed in a large number of colors. Within *ukiyo-e*, *shunga* exhibited the highest level of skill and expression. All well-known artists associated with *ukiyo-e* also drew *shunga*. Since these pictures included depictions of sex acts, there was little to no valuation of these productions for their artistic merit. However, Makoto Aida considers it "the purest form of truthful and original visual expression in Japan" and believes *shunga* has a deep connection with contemporary anime and manga. To make this connection apparent, he adapted a *shunga* work by Hokusai, *Taco To Ama* (Octopus and Shell Diver; fig. 86), for his piece *The Giant Member Fuji versus King Gidora* (fig. 87). King Gidora (or Ghidorah), who appears in the "Godzilla" series of monster movies, assails a figure wearing a uniform from the popular television series "Ultraman." The choice of motif is not uncommon among artists of Aida's generation, who incorporate elements of popular Japanese culture as a broad subtext for their work. In drawing on an animation cell, Aida creates an equivalence between modern-day animators and woodblock artists of the past.

会田誠《巨大フジ隊員VSキングギドラ》
Fig. 87: Makoto Aida, *The Giant Member Fuji versus King Gidora*, 1993. Acrylic and eyelets on acetate film. 310 × 410 cm.
Photograph by Hideto Nagatsuka. © Makoto Aida. Courtesy of Mizuma Art Gallery, Tokyo.

巨大フジ隊員VSキングギドラ

雪舟三十代画虹人
法橋永徳誠筆

Makoto Aida:
Zero Degrees of Japanese Art

Makoto Aida's art is challenging for most audiences. His references and the form of his artistic output have a sweeping scope, encompassing pop culture, fine art, politics, painting, performance, installation, sculpture, photography, illustration, and model-making. Even in his retrospective publication, *MONUMENT FOR NOTHING*, there is no chronological order nor thematic organization to the work; pieces are organized by some organic schema arising from the work itself. Aida explains the reason for this: "In my own private living quarters, the contents of my thoughts, the work I make—it is all in some strewn-out formation, which is actually what I am striving for." As a consequence, the most appropriate way to discuss Aida's particular body of work is as an accumulation of details and layers that interact with one another across style, medium, time, theme, and motif. The protean nature of his work is in itself a symbol of Japanese art's shifting character, which absorbs other traditions and styles. One of Aida's most recognized compositions is *The Giant Member Fuji versus King Gidora* (fig. 87), which is a borrowing of a composition by Hokusai (fig. 86). Though he has not directly inherited the school of Sesshū, in reviewing his work there are apparent influences along the lines of Kōrin Ogata (fig. 8), Hōitsu Sakai (fig. 49), Eitoku Kanō (fig. 4), Yoshitoshi Tsukioka, Kuniyoshi Utagawa (fig. 41), Tsuguharu Fujita, Kai Higashiyama, Hokusai Katsushika (fig. 77), Ikuo Hirayama, and Matazō Kayama—all the recognized masters of Japanese art seem to be present within Aida's work.

In the artist's choice of form, there are vestiges of gilded screens, hanging scrolls, or the composition of the four seasons (*shikisōboku-zu*) or the *suiboku* (drawing with India ink) of the Muromachi period. In that series, he is using a traditional technique of applying color to the support without the use any bounding lines that would serve as an outline for the figure that he is drawing. (This technique, which originated in China, is prevalent throughout Asia.) There are also aspects of his work that do not fit into any other category, such as his work with cockroaches—including a large-scale model of the insect in an erotic embrace with a naked woman. Aida says that cockroaches are "something within the frame of culture that humans have created (particularly in the traditional paintings of Japan), but when it comes to beauty, they fall outside of that scope. But if we look at it from a different angle, cockroaches do have a beauty—a structural beauty—which God (or biological evolution) has created as a paramount masterpiece."

Adaptation of the
Classics and Simulation

When questioned as to why he makes allusions to symbols of traditional Japanese aesthetics, Aida explained that in high school he was deeply influenced by the writing of Yukio Mishima: "His *Modern Noh Plays* was the model—the way he borrowed classic Noh forms—by which I wanted to express myself. There were other works that influenced me similarly. Toward the end of my school years, there was something of a movement called simulationism. It was a so-called highbrow type of parody that was quite popular in the art world then, and that greatly influenced me too."

In *Simulation and Simulacra* (1981), French theorist Jean Baudrillard described what he saw as a fundamental rift between the modern and the postmodern. Where modern society is based on the production and consumption of goods, postmodern society is based on the trafficking of images, signs, and codes. As a result, simulated experiences take on a greater reality than the outside world—a form of hyper-reality. In art, techniques shift toward cutting up, sampling, and remixing. Japanese art critic Noi Sawaragi cites the spread

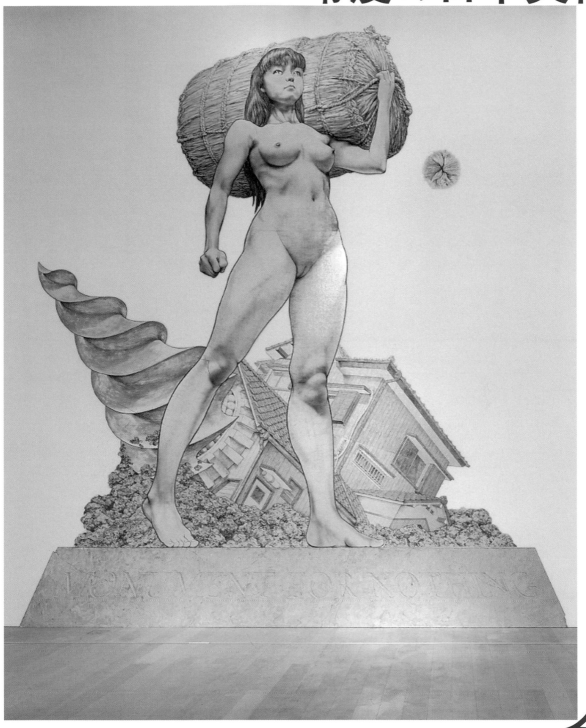

MONUMENT FOR NOTHING

Fig. 88: Makoto Aida, *Monument for Nothing*, 2004. 600 × 500cm, Plywood, hologram paper, acrylic, wooden screws.
Installation view from Roppongi Crossing. New Visions in Contemporary Japanese Art 2004 at the Mori Art Museum, Tokyo.
Photograph by Keizō Kioku. ©AIDA Makoto. Courtesy of Mizuma Art Gallery, Tokyo

会田誠

《MONUMENT FOR NOTHING Ⅲ》

Fig. 89: Makoto Aida, *Momument for Nothing III*, 2009. 750 × 1500 cm. Particle board, inkjet print, acrylic, wooden screws. Installation view from Wallworks at the Yerba Buena Center for the Arts, San Francisco, 2009. © Makoto Aida. Courtesy of Mizuma Art Gallery, Tokyo

of *simulation* from the beginning of the 1990s as having a tidal effect on the Japanese art world. Even though Baudrillard's ideas regarding simulation emerged from a culture with a completely different background than Japan, they share a similarity with the traditional Japanese technique of *mitate,* the tradition of making allusions to older work either by visual or textual reference, or even setting and function (page 21).

Japanese art historian Nobuo Tsuji writes in his book *Kisō No Zufu* (*Fantastic Illustration*) that kabuki researcher Masakatsu Gunji spoke of *mitate* as a practice in which "the actual thing itself has no meaning or device/plan. The actual thing does not please God." Borrowing these words, Tsuji describes the theory behind *mitate* as the essence of life for Japanese commoners (as opposed to its earlier noble class). The formation of art and craft creates a movement and becomes the basis of aesthetics. Simulationism can be seen as the same technique, in this case applied to mass consumer society and the critiques thereof, which emerged in the 1980s. The representative work of Aida, *A Picture of an Air Raid on New York City (War Picture Returns*; fig. 5) also makes extensive use of *mitate*. This view of Manhattan is reminiscent of Eitoku Kanō's *Rakuchū-rakugai-zu* from the eleventh century (fig. 4), with its symbolic fireballs of hell. The countless Zero fighters form an infinity symbol, but this serves a purely graphic function, keeping the eye locked in continuous movement over the surface of the painting. The cyclical nature of the figuration also intimates the perpetuity of vexed emotions surrounding Japan's defeat in the war.

A Japanese Technique That Allows One to Feel Affinity

From the latter half of the 1980s to the beginning of the 1990s Aida studied at art school; a number of his classmates were consciously trying to affect the conditions of Western art practice, so that their painting would have a universality. For Aida, natural painting does not depend on traditional cultures or arts; rather, it arises from contemporary *manga* and other such Japanese modes of expression. He comments:

"A lot of people cite *ukiyo-e* as a typical Japanese style of painting. Filling in flat color in the black outline—in a way, it is a childlike way of drawing. The surface of it is quite particular, I think. In Western painting, the surface is more bold, more constructed, the shading and contrasting is quite dramatic and gives the three-dimensionality a great deal of realness. For that reason it lends itself to oil painting. In Japan it is more about the ornamentation of the surface or the material feeling of the surface, which is *more* skillful and ingenious. That is particularly the case in drawing manga. In American comics, light and shade are quite distinct from one another. In Japan, the gray screen tone is applied and from that, using a cutter, the unneeded areas are removed. So, they are almost building the form by sculpting the form. Manga artists too are not trying to draw images that are necessarily Japanese per se. But both Western and Japanese approaches have an innate expression to them that relates to their ethnicity. Another innate Japanese quality, if we consider the loss of beauty Zen, is Tokyo's discount electronics store district, Akihabara, with its neon signs and lack of planning and order in its random assortment of buildings. It is going in the opposite direction of what it once meant to be beautiful. But I like it in a visceral sort of way."

The filthy signs of Akihabara, in their disarray, form the basis for a recent series by Aida called *MONUMENT FOR NOTHING*. "It's very nonsensical, there is no thing that is being communicated or emphasized. It is not beauty as such. In us there is a type of work that doesn't have anything to emphasize. Just as prime ministers change with such rapid succession, we make work that has the same playful twisting. In Japan art is beauty, things that feel nice, and so-called *kachō-fūgetu* (a composition showing the splendors of nature); there are many items that present something that is emphasized, whereas outside of Japan art seems to have a lot of social pronouncements, serving as something didactic." The kind of message-based construction—or "meaning" in Western terms—is something less apparent in traditional Japanese art. Where Western art is organized around the impulse to communicate some message (based in logos), Japanese art seems wholly at ease with communicating "nothing."

In his book *Empire of Signs*, Roland Barthes describes in a phrase what Aida feels for Japanese society in reference to the makeup of Tokyo as a metropolis. "The city that I am trying to discuss, Tokyo, is like the following paradox: This city has a center. However, that center is a void. There are forbidden areas, at the same time it is an insignificant place; wrapped in green, it is defended by a moat, and it is a place that remains unseen by anyone; the Imperial Palace, the city is built up around it. In this circle's low point, there is an invisible visible shape, that is the sacred *mu* (cf. chapter 7, page 145). However, in this center that this is, it is not there to radiate some power, it gives movement of the city a hollow center, for the endless enforced detour of circulation of movement, that is what it is there for. In this way, a hollow subjective 'unreal' phenomenal world detours and changes directions, circulating as it expands."

Aida's *MONUMENT FOR NOTHING* is the hollow center that Barthes describes enveloping Tokyo. This paradox—to be defined as a state of absence, or emptiness, or nothingness—is an essential dynamic of Japanese art and the "center" (or degree zero) of Aida's work. Circling in the air like the Zero fighters over Manhattan, collapsing dichotomies high and low culture, then and now, beauty and revulsion and eviscerating any tangible statement from his work, Aida is a problematic yet quintessential contemporary Japanese artist.

EMPTY

(*mu*)

Neither Nothing nor Something

In Japan, artists and artisans who demonstrate mastery of skills in the performing arts (such as music, theater, or dance) and crafts (including ceramics, textiles, doll making) are honored as living national treasures. These designations are made by the Foundation for Intangible Culture, which was established in postwar Japan to recognize the value of "objectless" art and to foster their preservation and continuation. (UNESCO, seeing Japan's example, established the Intangible Cultural Heritage in 2003 to help preserve similar art practices throughout the world.) Valuing something that is not physical is certainly an interesting idea—at the core of which rests the concept of *mu*.

In the substance-centrist West, the idea is not only difficult to describe but also is generally ascribed a negative value. In the East, however, there are countless examples of *mu*, and this seeming void is given greater value over material output. Of course, this is not exclusive to Japan; it is an idea that can be seen throughout Asian cultures, including Indian philosophy, Zen, and the Taoist philosophy of Laozi (Lao Tzu) and Zhuangzi (Chuang Tzu), each of which has *mu* as its base. In Japan, however, this philosophy of *mu* was connected with worship of nature and ancestors—native immutability. The extent of the influence of this new combination is inestimable. The philosophy of *mu* is not limited to religion, but comprises art and folk tradition, too. There is an aesthetic for artwork that does not reveal traces of handiwork, leaving nature as it was found—an artifice that disguises its own craft. Dating back to the poetry of the Nara period, there are expressions of appreciation for the simple and rustic quality of wood that still has its bark; a sensibility that relates to *wabi-sabi*. Just as discourse in Japanese language can function without the incorporation of a subject, an anonymity that transcends selfhood, the sensitivity to silence also is incorporated in this idea of *mu*. The limitlessness of the cosmos and the finite nature of all forms arising and passing away—all this contained in the sublime concept of *mu*.

町田久美《レンズ》

Fig. 90: Machida Kumi, *Lens*, 2007. Sumi ink, mineral pigments, pigments, pencil, color pencil on kumohada linen paper. 53.5 × 45.5 cm. Courtesy of Nishimura Gallery, Tokyo.

Smooth Lines of Handicraft

Upon first glance Machida Kumi's work looks like a woodblock print (fig. 90); her strictly controlled and homogenous outlines of the figure show no element of a brush stroke. If we pay close attention to the details, however, we can see that within an ostensibly consistent line there is a bluish black, a brownish black, and, alongside the outline, there is a pale black that conveys a nuance of shadow. In fact, Machida draws her lines using a fine brush, painstakingly inking in the lines

《能面 (花の小面)》(重文)

Fig. 91: Tatsuemon (attributed), Noh mask: *Hana no Koomote* (Flower), Muromachi period. Designated Important Cultural Property. Hinoki (Japanese cypress) wood, color. Mitsui Memorial Museum.

layer upon layer, thereby eliminating any trace of her handiwork. Making a *Nōmen* (Noh mask; fig. 91) also requires a many-staged process of shaping, working, and finishing raw wood to yield the perfectly smooth and seemingly supple surface of a mask of a female face. Removing layers with sandpaper to create the mask's surface is like the building up of fine lines in Machida's drawing; the actions are opposite, but the results are the same.

能面十町田久美

奈良美智《Fountain of Life》
Fig. 92: Yoshitomo Nara, *Fountain of Life*, 2001. FRP, pigment, polyurethane, motor, water. 175 × 180 cm. Photograph by Norihiro Ueno. © Yoshitomo Nara. Courtesy of Tomio Koyama Gallery, Tokyo.

Return to the Innocence of Childhood

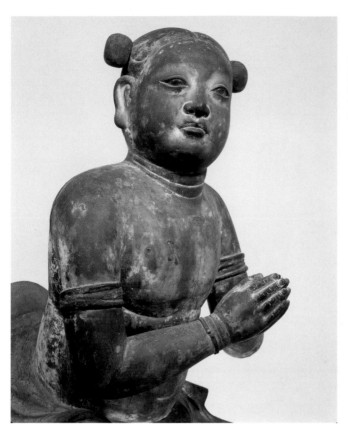

《善財童子》(重文)
Fig. 93: *Sudhana* (Child of Wealth), 1302 (Kamakura period). Designated Important Cultural Property. Wood, gold embellishments, crystal. 86 cm. Saidaiji Temple, Nara. Photograph by Nara National Museum, Kinji Morimura.

Sudhana was originally born to an affluent family in India, but in seeking enlightenment he made a pilgrimage to fifty-three teachers, from whom he learned Buddhist teachings. Among Buddha figures, this is a small form (fig. 93)—the Bodhisattva looks upward, absorbing the wisdom of the material world while expressing the purity and innocence of its spirit. In addition to this statue, there are numerous other instances where the Buddha is depicted as a child, expressing a similar purity. After being imported from China in the mid-sixth century, it is thought that such statues were made extensively in the Nara period (eighth century), by which time the form of the child Buddha was refined, and through it a long-standing tradition for expressing innocence and purity in Japanese Buddhist art was established. According to one telling, in ancient times children were thought to be vessels that the gods inhabited and, as such, were revered as a sacred connection between gods and humans. Artist Yoshitomo Nara uses children as a primary motif in his work, often incorporating aspects of their innocence in addition to their petulance. In his sculpture *Fountain of Life* (fig. 92), the expression of the children is solemn—as if in prayer or meditation—yet streams of water flow down from their eyes, which could be seen as a cleansing attribute, returning the viewer to a state of purity.

円空《雨宝童子像》
Fig. 94: Enkū, *Uhō Dōji*, 1676 (Edo period). Wood. Arako Kannonji Temple, Nagoya. Photograph by Mori Art Museum.

三沢厚彦《Animals 2008-04》
Fig. 95: Atsuhiko Misawa, *Animals 2008-04*, 2008. Camphor wood and oil paint. 40 × 86 × 37 cm.
Courtesy of Nishimura Galley, Tokyo.

Emergence/Appearance

Atsuhiko Misawa's animal sculpture (fig. 95) and the tenth-century Buddha figure by Enkū (fig. 94) appear to share a rough-hewn quality; in both we can see traces of the blade's edge on the wood. This style of Buddha sculpture was intentionally left unfinished; the coarsely chiseled surface conveyed the moment just before the Buddha fully emerged. In this state, the Buddha is still in the process of emerging, conveying the heightened spiritual charge of what is contained in the wood. Misawa says this: "The work directs me to make some parts more plain and others more sharp. And then at a certain point, the way in which I relate to the work totally changes. That is the moment that the spirit of the wood transforms into sculpture." The chop marks of the chisel, the bold, expressive elements that have been excavated, and the undeniable presence of the wood itself—superficial technique reveals the artistic and spiritual quality within.

Contemporary Zen

しりあがり寿《双子のオヤジ》
Fig. 96: Shiriagari Kotobuki, *Futago No Oyaji* (Middle-aged Twins), 2000. Paper, Sumi ink, watercolor, artist's seal. 33.7 × 24.3 cm. Collection of the artist.

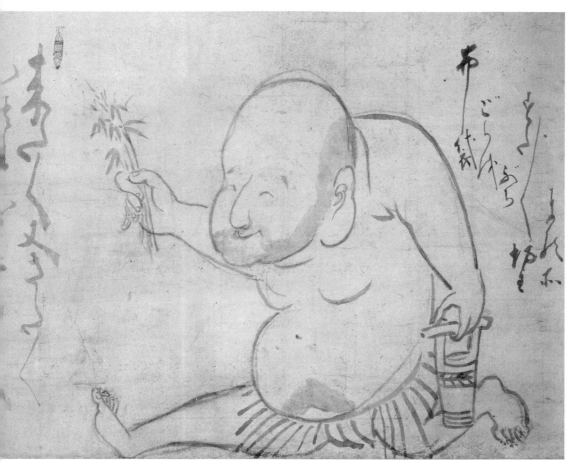

白隠慧鶴《布袋すたすた坊主》

Fig. 97: Ekaku Hakuin, *Sutasuta Bōzu* (Running Monk), Edo period (18th century). Sumi ink on paper. 52.8 × 94.0 cm. Aizu Museum, Waseda University.

The ambling saunter of the Zen monk (fig. 97) and the twin *oyaji* (middle-aged men; fig. 96) convey a litheness of spirit and motion. They are completely nude, with smiles of supreme bliss, and engaged simply in frolic. This image of *oyaji*, drawn by manga artist Shiriagari Kotobuki, is wholly removed from the more earthly image of a middle-aged man, with his concerns for family, company, and social status. Stripped of all material possessions, they have found bliss. Similarly, the dancing monk of Hakuin's drawing is in an equivalent state of liberation. Here we see the potbellied monk on his way to temple to pray in the stead of a wealthy person, who has paid the monk some coins for the service. Hakuin has overlaid that image with the Seven Gods of Good Fortune, with their rotund stomachs. It is said that the image of Hotei is an alter ego for Hakuin. Meanwhile, the twin *oyaji* are separated from the earthly world; theirs is an unworldly existence, and there are no other humans nearby. The choice of twinship as a theme is one of self-reflection, the basis of enlightenment. Shiriagari Kotobuki's *Zen-ga* is a contemporary expression of Zen Buddhism.

Zen Consciousness of the Ring

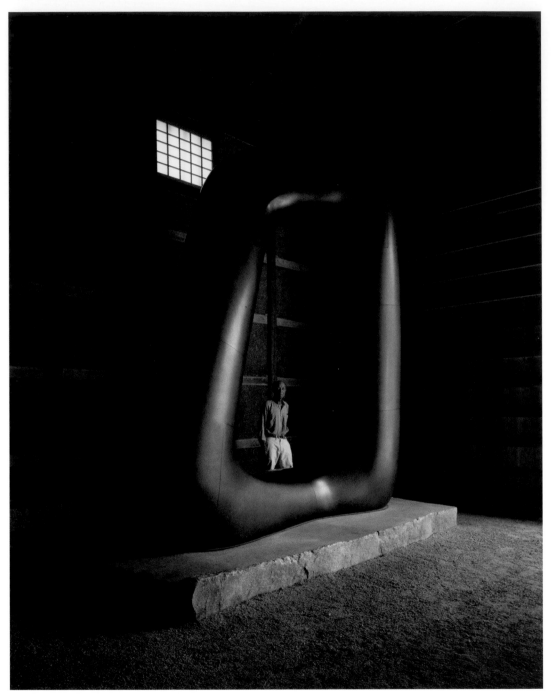

イサム・ノグチ《エナジー・ヴォイド》
Fig. 98: Isamu Noguchi, *Energy Void*, 1971–72. Swedish black granite. 360 cm. The Isamu Noguchi Garden Museum, Japan/ARS, New York/SPDA, Tokyo.

《茅の輪》

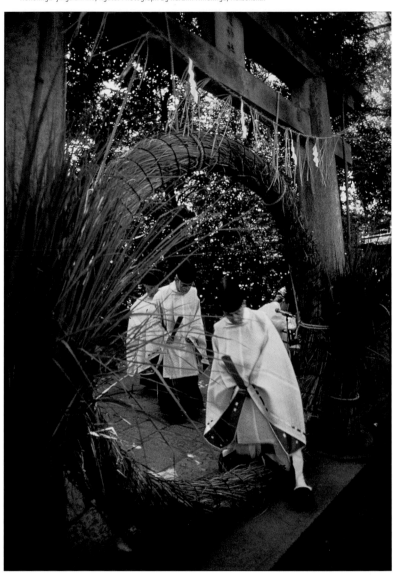

Though Isamu Noguchi is Japanese-American, his childhood sensibility for art came from his experiences in Japan. He labored to "bring back to life the Japan within" whenever he tried to express something in his art. To express the "wandering heart" loss of equilibrium he felt living between two cultures, Noguchi used the motif of a hollow circle (fig. 98). This shape first appears in his work in 1951, when the artist was thirty-six and visited Japan for the first time in nineteen years. The title of the work is *Mu* (nothingness). Plainly, Noguchi was making a clear reference to the Zen consciousness. In Japan the circle has long symbolized a "return to nothingness" or "born from nothingness"; it is considered the origin of energy and as such is a highly charged formation. At the time of *Ōharae* (the semiannual ritual of visiting a temple for absolution) a circle of thatch is constructed; it is believed to have the ability to rid one of impurity and pestilence (fig. 99). From the 1960s onwards, the circle became a favored form in Noguchi's work. The apotheosis of this is the *Energy Void*. For Noguchi, the circle equals the space of nothingness (void) and at the same time, it is also from this zero that limitless energy is released.

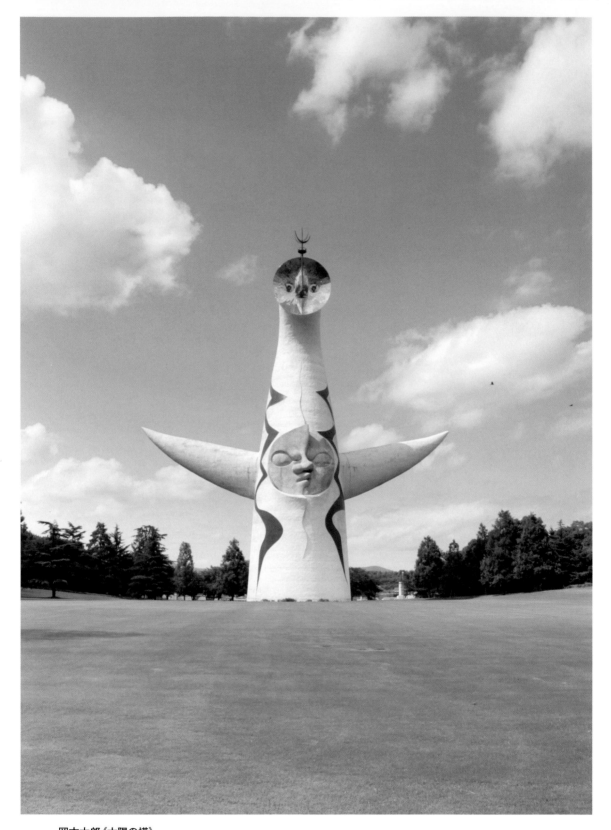

岡本太郎《太陽の塔》
Fig. 100: Tarō Okamoto, *Tower of the Sun*, sculpture for World's Fair held in Osaka, 1970. Steel frame and concrete, stucco.
70 × 20 m., arm span: 25 m. Expo Commemoration Park, Osaka.

Earthenware of the Jōmon period was recognized within Japanese art history only in the last half-century. In the autumn of 1951, at the Tokyo National Museum, one of Japan's most beloved artists, Tarō Okamoto, saw Jōmon-period earthenware (fig. 101) displayed as archeological materials of study. He felt they possessed an extreme strength and invoked an unparalleled spirituality (godliness), and he believed he had found an "ultra-contemporary Japanese aesthetic": "In coming into contact with Jōmon earthenware, I found strength in my blood. It opened my eyes to the expansive and a new 'traditional' that lay hidden in the depths of our culture and the soil of our nation. This is not only for one race. This is a deep connection with the origins of humanness and faith."

Okamoto soon became engaged in a vigorous investigation of the pure power of creativity in clay figures and Jōmon culture, as well as other traditional cultures of Japan. As a result, he diverged completely from his European-style training as an artist, which he is how he began his artistic career. The 1970 World Expo in Osaka was Japan's opportunity to demonstrate to the world the extent of its postwar recovery. Okamoto served as the producer for this event, and made *Tower of the Sun* (fig. 100), inspired by a clay figure. Clay figures with breasts are common throughout primitive art globally; the female image also is common, as a prayer for fecundity and prosperity and the passage of life-force from one generation to the next. The *Tower of the Sun* similarly conveys the significance of life force. The head, abdomen, and back all have a face formation, representing the future, the present, and the past in turn. At the same time, this expresses the ceaseless continuation from past to future, and the eternal nature of the life force.

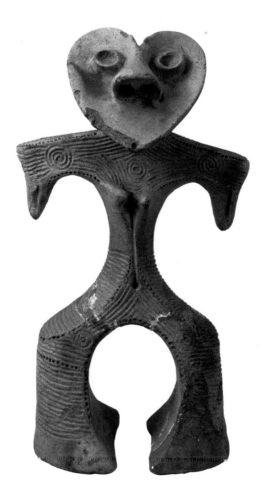

Rediscovering Japanese Aesthetics: The New Traditional

《ハート形土偶》（重文）

Fig. 101: Late Jōmon period heart-shaped earthenware. Important Cultural Property. Clay. 30.5 cm. Unearthed in Gunma. Private collection on loan to the Tokyo National Museum. Image: TNM Image Archives Source: http://TnmArchives.jp

宮島達男《Mega Death》
Fig. 102: Tatsuo Miyajima, *Mega Death*, 1999. Installation at Opera City Art Gallery. L.E.D., integrated circuit, electric wire, motion sensors. 500 × 3400 × 1.8 cm. Photograph by Norihiro Ueno. Courtesy of the Japan Foundation, SCAI THE BATHHOUSE, Tokyo.

An Infinite Set

In Buddhism, everything in this world—all extant phenomena—is imbued with the spirit of Buddha, and this cosmos is also infinite. The elephant, leopard, and many other animals depicted in Jakuchū's *Birds, Animals, and Flowering Plants in Imaginary Scene* (fig. 103) did not exist in Japan. They were bizarre beasts drawn from the imagination. In this manner, the worldview evoked in such multiplicity on this folding screen shows that all things under the sun will attain enlightenment and reach nirvana. In an assembly of more than 86,000 individual squares of approximately one centimeter each, the technique of drawing each square itself is visible, revealing a Buddhist consciousness. Each square is in itself an abstract form, but seeing the countless assembly of squares in the painting brings a unity and wholeness into view. Similarly, in Tatsuo Miyajima's *Mega Death* (fig. 102), a seemingly infinite number of counters combine to form a cosmos. The flicker of each counter represents the life and death of one person. Counting down from nine, the counter goes dark at the moment it should flash zero. Once again it lights up and starts counting down, repeating endlessly. This cycle of birth and death reveals in its renewal the cycle of reincarnation.

伊藤若冲 ＋ 宮島達男

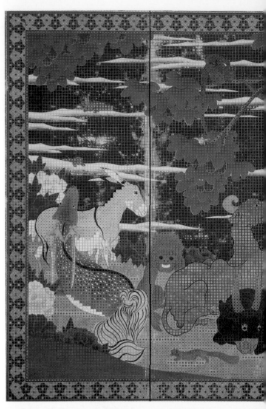

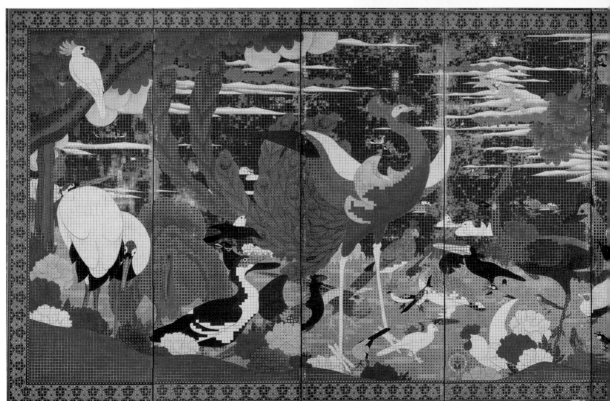

伊藤若冲《鳥獣花木図屏風》

Fig. 103: Jakuchū Itō, *Birds, Animals, and Flowering Plants in Imaginary Scene*, Edo period (late 18th century). Pair of six-panel folding screens; colors on paper. Each panel 168.7 × 374.4 cm. Photography by Shigeharu Omi. The Etsuko and Joe Price Collection.

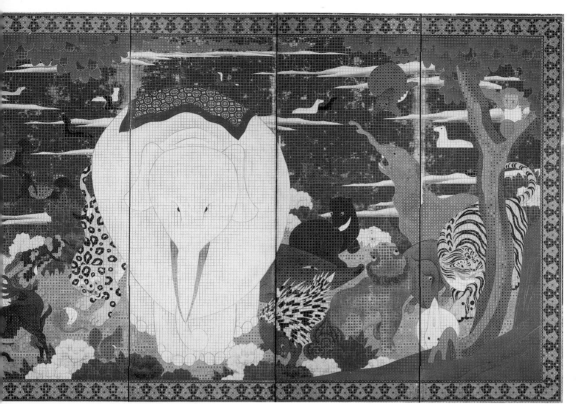

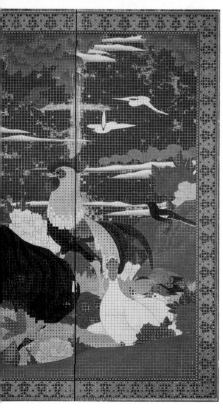

Artists' Profiles

FEUDAL JAPAN

康勝 Kōshō
Sculptor of Buddhist images, birth and death unknown,
Kamakura period.
While his birth and death dates remain unknown, Kōshō was the son of the well-known sculptor Unkei. In the early years of the Kamakura period, following in the footsteps of his father and his uncle Tankei, he created statues of the two deva kings (guardian gods of Buddhism) at Kyoto's Tō-ji temple. From approximately 1209, he made the Buddha statues at Kōfuku-ji temple, one of these statues was transferred to Kōzan-ji temple in 1223. Kōshō also is attributed with creating Sō-Kōshō, an undated sculpture of a Buddhist monk, which is considered a masterpiece of Japanese sculpture.

雪舟 Sesshū
Painter and Monk, 1420–[1506], Muromachi period.
Born in Bichū (present-day Okayama prefecture), Sesshū joined Kyoto's Shōkoku-ji temple at a young age. In his forties, he was transferred to the castle town of Yamaguchi, from where the powerful Ōchi family reigned over the region. There he mastered Seppa, a prevalent artistic style introduced from Ming dynasty painters. For the Ōuchi family he produced Landscape of Four Seasons. Using techniques derived from the basics of Song and Yuan dynasty painting, he started a series of Sansui-ga paintings (mountain and water paintings) as well as Kachō-ga (flower and bird paintings), creating masterpieces in each genre.

雪村 Sesson
Painter and Monk, birth and death unknown,
Muromachi period.
Born in Hitachi (present-day Ibaraki prefecture), the birthplace of the daimyō (feudal lord) Satake. At a young age he entered the priesthood. While studying the painting styles of the Song and Yuan dynasties, he was mostly self-taught. In his fifties, he left Hitachi and traveled throughout modern-day Japan, which at the time was composed of autonomous regions. During this time, he perfected his soft-brush painting technique. This unique style expressed tension and ease at once. It is said he lived well into his eighties and continued to paint until his death.

千利休 Sen no Rikyū
Tea master, 1522–91, Muromachi period.
Born in Sakai (in present-day Osaka prefecture) to a merchant with the trade name Totoya, Sen no Rikyū was hired as the head of tea ceremonies after the daimyō Nobunaga Oda took direct control of Sakai. Rikyū later served Hideyoshi Toyotomi. He also presided over a tea ceremony called the Kitano Daichakai, and greatly influenced the form of the tea ceremony. He was highly respected by Hideyoshi as a tea master, but Hideyoshi ordered him to commit suicide by seppuku (ritual disembowelment) at the age of seventy. Rikyū established the style of wabicha, which eliminates all extraneous elements from the performance of the tea ceremony.

長次郎 Chōjirō
Tea master, birth and death unknown,
Azuchi-Momoyama period.
This pottery master founded the Raku school. Under the leadership of Sen no Rikyū, he served as a tea master for Toyotomi Hideyoshi. At the request of Rikyū, he produced a tea cup by hand (without the use of a wheel), in a style that was known as "tea bowls of the Sōeki form," because Rikyū was commonly known as Sōeki. His tea bowls have since assumed a special status in the world of tea ceremonies.

長谷川等伯 Tōhaku Hasegawa
Painter, 1539–1610, Muromachi and Azuchi-Momoyama periods.
Born in Noto (present-day Ishikawa Prefecture), Hasegawa began assisting in the production of Buddhist paintings in his youth. In his thirties, he moved to the capital, where he advanced from painting portraits to painting sliding doors that were virtually indistinguishable from the work of the Kanō-ha school of painters. For Hideyoshi Toyotomi he produced wall paintings that rejected the Kanō school style and created masterpieces. Studying Song dynasty painting from Southern China, he went on to create Pine Forest, his representative work, a masterpiece of sumi-e ink painting.

狩野永徳 Eitoku Kanō
Painter, 1543–90, Muromachi and Azuchi-Momoyama periods.
The first grandson of Motonobu Kanō, a key painter of the 16th century, Eitoku Kanō exhibited an innate talent for painting from childhood. At the age of twelve, Yoshiteru Ashikaga requested that he draw the screen Rakuchū-rakugai-zu (fig. 4), and he later painted for Nobunaga Oda and Uesugi Kenshin. His brilliant style of drawing was a popular attraction for many, and his work adorned Azuchi Castle and Osaka Castle. In his later years, struggling with the rise of the Hasegawa school of painters, he is reported to have died of overwork.

長谷川久蔵 Kyūzō Hasegawa
Painter, 1568–1593, Muromachi and Azuchi-Momoyama periods.
Born in Nanao, Noto province (present-day Ishikawa prefecture). The eldest son of Tōhaku Hasegawa, Kyūzō Hasegawa surpassed his father's skills and stood out among the various factions of the Hasegawa school. Hideyoshi Toyotomi, mourning the death of his son, erected Shoun-ji temple, for which Kyūzō produced a screen painting of gilt with a motif of cherry trees (fig. 47), his last work before his untimely death at the age of twenty-six.

俵屋宗達 Sōtatsu Tawaraya
Painter, birth and death unknown, Azuchi-Momoyama and Edo period.
Tawaraya had a close friendship with the craftsman Kōetsu Hon'ami while creating a strain of the Rimpa school of painting, which inherited the traditions of *Yamato-e*. Even with his sumi-e ink drawings, he pursued a heightened sense of surface awareness, thereby creating a unique style. He produced many types of work, some of which include: fan painting, stationery design, scrolls, and screens. His screens became a standard of Rimpa, influencing Kōrin Ogata and Hōitsu Sakai.

本阿弥光悦 Kōetsu Hon'ami
Craftsman, 1558–1637, Azuchi-Momoyama and Edo period.
Hon'ami was born to a family that worked in sword polishing and appraisal for many generations. He was engaged in various fields of art—painting, ceramics, and lacquerware—and became a central figure in the cultural circles of Kyoto. Under the aegis of Ieyasu Tokugawa, in north Kyoto, he developed ties with the Hokke faith. From his late forties the scopes of the disciplines he practiced broadened further. His tea bowls, in particular, demonstrate a heightened artistic sensibility.

EARLY MODERN JAPAN

狩野山雪 Sansetsu Kanō
Painter, 1590–1651, Edo period.
At the age of sixteen he became an apprentice of Sanraku, who belong to the Kanō school and later adopted Sansetsu. Beginning with ceiling paintings and screens in the tradition of Sanraku, he created many bold works at several temples. As seen in Old Plum Tree (fig. 22), he was able to exercise a geometric deformation and modeling in his compositions, showing his penchant for the artificial. Later in life he was imprisoned for unknown reasons and died shortly after his release.

円空 Enkū
Buddhist Monk, 1632–95, Edo period.
In the early Edo period, Enkū was an itinerant maker of Buddhist sculptures. After leaving his home in present-day Gifu prefecture, he traveled to various corners of pre-unification Japan. Using a chisel and a hatchet to create roughly wrought shapes, his work left the living spirits of the wood intact. It is said that he aspired to create 100,000 sculptures in his lifetime, and several thousand specimens of his sculptures remain throughout the country.

白隠慧鶴 Ekaku Hakuin
Buddhist Monk, 1685–1768, Edo period.
Mid-Edo period Buddhist monk. He revived Rinzai Buddhism from a period of dormancy. From early childhood, he was plagued by violent hallucinations and at the age of fifteen he left home to make a pilgrimage across the land. He studied with Shōju-Rōnin, who lead him to enlightenment. From middle-age onward, Hakuin Ekaku was active at Shōin-ji temple, where he served as an abbot. Though he showed a proclivity toward drawing from his youth, he was almost entirely self-taught and maintained an uninhibited use of brushes. His extant works were mostly drawn from the age of sixty onward, his most prolific period.

尾形光琳 Kōrin Ogata
Painter and designer, 1658–1716, Edo period.
Born to a wealthy merchant in Kyoto. From an early age, he was acquainted with the works of Sōtatsu and Kōetsu. He initially studied Kanō-ha and was strongly influenced by Sōtatsu, and labored for the re-establishment of the Rimpa style of painting. From the time he inherited his father's estate, he devoted himself solely to painting. From his forties, his style was characterized by an intellectual and elaborate sensibility. He also extended his talent to lacquerwork and kimono design.

伊藤若冲 Jakuchū Itō
Painter, 1716–1800, Edo period.
A mid-period painter. After working as a vegetable wholesaler in Kyoto, he first started to study the Kanō-ha style of painting but was left unsatisfied and was instead drawn to one of Kyoto's greatest Zen Buddhist temples, Shōkoku-ji temple, presided by 18th century Zen monk Daiten Kenjō, with whom Jakuchū felt a strong kinship. Jakuchū studied traditional Chinese paintings and Ming and Ching dynasty paintings extensively. His use of vivid colors paired with the sharp, contoured definition of component parts gave his compositions a rhythm and intensity. Several of his works retain their uniqueness even today.

鈴木春信 Harunobu Suzuki
Ukiyo-e artist, 1725–1770, Edo period.
Mid-period ukiyo-e artist. He studied Yamato-e under Nishikawa Sukenobu in Kyoto. At the age of thirty-five, he returned to Edo (present-day Tokyo), where he first made illustrations for prints but later concentrated exclusively on bijin-ga (prints of beautiful women). He was in charge of creating elaborate e-goyomi (painting calendars), commissioned by a newly formed trade association for the form. He also mastered the art of printing with ten colors, preparing lushly colored works that were commercially successful. The poetry and refined images he produced reflected the spirit of the Edo period and contributed greatly to establishing the tradition of multi-color printing.

曾我蕭白 Shōhaku Soga
Painter, 1730–81, Edo period.
Born in Kyoto to a merchant household. He studied the popular Kanō-ha style of painting. In pairing and contrasting sumi ink and pigment, he created an overall disharmony on the painting plane that was unique and dynamic. He was regarded as unconventional, and once said: "If you want something artistic, come to me; if you want something functional, go to Ōkyo Maruyama".

円山応挙 Ōkyo Maruyama
Painter, 1733–95, Edo period.
Mid-period painter. Was born to a farming family in Kyoto's northern region. After moving to Kyoto, he studied the Kanō-ha style. In this youth, he made megane-e (eyeglass paintings) that were drawn specifically for a viewing apparatus that enhanced the sense of perspective, affecting that found in Western painting styles. He studied many different techniques, including that of traditional Chinese painting, and Ming and Ching dynasty painting. He became a principal of Kyoto's painting circles with his traditional expression and ornamentation paired with verisimilitude. He had many

apprentices, who formed a major faction in the painting circles of the late Edo period.

喜多川歌麿 Utamaro Kitagawa
Ukiyo-e artist, [1753]–1806, Edo period.
Late Edo-period ukiyo-e woodblock print artist. A student of Toriyama Sekien, he followed the precedent of ukiyo-e artists Kito Shigemasa and Torii Kiyonaga's bijin-ga. Edo's greatest publisher of prints, Tsutaya Jūzaburō, was impressed by his work and in 1790 produced the first series of popular prints. The evocative close-up portraits of beautiful women drew mass appeal. He was imprisoned under Tokugawa Bakufu's entertainment regulations, however, and died two years later.

葛飾北斎 Hokusai Katsushika
Ukiyo-e artist, 1760–1849, Edo period.
Late-period ukiyo-e artist and printmaker. Born in present-day Tokyo, he studied all painting styles available to him, including Kanō-ha and Tang, under Katsukawa Shunshō. He lived to the age of ninety and in that time addressed nearly every theme and artistic style possible. He changed his moniker some thirty times, moved ninety-three times, and left a body of work exceeding 30,000 specimens. His most legendary work is Thirty-six Views of Mount Fuji, with the iconic mountain a constant theme in his work. He is broadly recognized outside of Japan as well, influencing artists such as Van Gogh, Cezanne, and other Impressionists.

酒井抱一 Hōitsu Sakai
Painter, 1761–1828, Edo period.
The second son of the daimyō of the Sakai clan of the Himeji Domain. In his adolescence, he tried his hand at comic verse and ukiyo-e but, at the age of thirty-seven he began his studies in the Kanō-ha. He studied under Utagawa Toyoharu and eventually became a painter of the Rimpa school. He is credited with reviving the style and name recognition of Kōrin Ogata with his lively and delicate renderings of flowers in the rain, wind, and moonlight.

歌川国芳 Kuniyoshi Utagawa
Ukiyo-e artist, 1797–1861, Edo period.
Late-period ukiyo-e artist. He was born to a silk dyer in Edo's Nihonbashi district. At the age of fifteen, he became an apprentice to Utagawa Toyokuni. His name came to be closely identified with Musha-e (depictions of warriors). His large-scale works made extensive use of narrative but he is only recently gaining recognition compared to his renowned contemporaries, Hokusai and Hiroshige.

歌川広重 Hiroshige Utagawa

Ukiyo-e artist, 1797–1858, Edo period.

Late-period *ukiyo-e* artist. Born to the Andō family of fire fighters. From an early age, his interest in art was strong and he became an apprentice of Utagawa Toyohiro. His drawings centered on Kachō-ga (bird-and-flower painting), but shifted to landscapes with the death of his teacher Toyohiro. His representative works are praised for their use of perspective and the dimensional expression of rain. He has influenced numerous foreign artists, and the Japonisme movement in turn-of-the-century Europe termed the vibrant indigo he used "Hiroshige Blue".

上村松園 Shōen Uemura

Painter, 1875–1949, Meiji, Taisho, and Shōwa periods. Born to a tea seller in Tokyo. From an early age, she demonstrated artistic skill and attended a school for the arts. From Meiji 33 (1900), when she exhibited at the third National Trade Fair, her work quickly drew attention and praise. In Shōwa 23 (1948), she was the first woman to be awarded the Order of Culture. Her work concentrated on Kyoto culture and classical literature, using an economy of line and form, while also incorporating a particular use of color. Her paintings commonly depicted women.

イサム・ノグチ Isamu Noguchi

Sculptor, 1904–88, 1920s.

Born in Los Angeles to English literature professor Yonejirō Noguchi and writer Leonie Gilmour. During his early years he was raised in Japan. After moving to the United States, he resolved to become a sculptor. Later he worked as an assistant to Constantin Brâncusi in Paris. After working in the performing arts, his social circle included the architect Kenzō Tange, imperial envoy Hara Sōfū, and avant-garde artists of the time such as Tarō Okamoto. Using pottery and washi (Japanese paper) he also created lantern designs called Akari, as well as a number of environmental sculptures in the United States and Japan. He came to be known as "the man who sculpted the world."

重森三玲 Mirei Shigemori

Landscape Gardener, 1896–1975, 1930s.

Born in Okayama. In his early years, this Shōwa-era landscape artist and garden historian was greatly enamored with tea ceremonies, and studied Nihon-ga (Japanese painting) at art school. He also was an advocate of ikebana flower arrangement. In 1936 he made a nationwide survey of gardens, which became the foundation for a history of Japanese gardens. He has created more than 200 gardens, including those at Tōfuku-ji Hōjō (fig. 26), Daitoku-ji Institute, and Matsuo Grand Shrine. He wrote the *Illustrated Book on the History of the Japanese Garden* (26 volumes), among many other titles.

岡本太郎 Tarō Okamoto

Multidisciplinary artist, 1911–96, 1940s.

Born in Kanagawa, the first son of manga artist Ippei Okamoto and author Kanoko Okamoto. While traveling in Europe he was greatly influenced by the abstract art works of Picasso. After returning home, he opened a studio in Tokyo, and began working as an avant-garde artist alongside contemporaries such as Hanada Seiki. In 1952, he first encountered Jōmon culture at the Tokyo National Museum, and actively started exploring that culture, as well as those of Okinawa. Emphasizing the

public nature of art, he designed Olympic medals for the Tokyo and Munich games, and the symbolic sculpture of the 1970 World Expo in Osaka (fig. 100).

柳宗理　Sōri Yanagi
Industrial Designer, b. 1915, 1940s.
Born in Tokyo. His father was Sōetsu Yanagi, a researcher and historian of mingei (Japanese folk crafts) and member of the Shirakaba-ha (a school of modern writers). In 1934 he entered the oil painting department of the Tokyo University of Arts but, influenced by mingei and having met Le Corbusier and Charlotte Perriand, he changed course and became a designer. In 1952 he established the Yanagi Industrial Design Research Association. His work includes his well-known Butterfly Stool, Olympic torches, flatware, and cutlery.

草間彌生　Yayoi Kusama
Avant-garde sculptor, Painter, Novelist, b. 1929, 1950s.
Born in Nagano Prefecture. From childhood, her field of vision was obscured by a polka-dot pattern. She spoke with plants and animals and produced drawings that were directly inspired these hallucinatory experiences. Her painting is typified by repetition and proliferation of net and dot patterns, which intimates the presence of the limitless and intangible in a world that is overly systematized.

仲條正義　Masayoshi Nakajō
Art Director and Graphic Designer, b. 1933, 1950s.
Born in Tokyo. After graduating from the Tokyo University of Arts in 1956, he worked in the advertising division at cosmetics company Shiseidō. After this, he engaged in extensive free-lance work and in 1961 established the Nakajō Design Office. Since then, he has served as the art director of the Shiseidoō culture magazine, "Hanatsubaki," worked in department store design direction, package design, and created the corporate identities of many firms. He is the recipient of numerous design awards.

赤瀬川源平　Genpei Akasegawa
Avant-garde artist and writer, b. 1937, 1950s.
Born in Kanagawa. Quit his studies at Musashino Art School and formed the performance group Hi-Red-Center. In 1979, using a pen name, he made his literary debut as the author of "Hada zawari" (Soft to the touch) and won the Akutagawa Prize in 1981 for the short story "Chichi ga kieta" (Extinguished). In 1983, upon receiving a newcomer award, he quit literature. He has also written manga, screenplays, and is a member of the Japanese Art Rally Group, among other organizations.

横尾忠則　Tadanori Yokoo
Painter and Graphic Designer, b. 1936, 1960s.
Born in Hyōgo Prefecture. He is a graphic designer, illustrator, printmaker, painter, and is recognized internationally as a graphic artist. More than fifty years since making a splashy debut as an artist, Yokoo continues to be constant presence in contemporary arts in Japan. In recent years, he has had exhibitions at: the Tokyo Museum of Contemporary Art; the National Museum of Modern Art, Kyoto; the 21st Century Museum of Contemporary Art, Kanazawa; and the Fondation Cartier Pour l'Art Contemporain, Paris. He has published more than 200 books and catalogs.

荒木経惟　Nobuyoshi Araki
Photographer, b. 1940, 1960s.
Born in Tokyo. In 1963, he was employed at the advertising agency Dentsū as a staff photographer. He held several exhibitions and self-published many of his own photobooks, but did not become independent until 1970. His work is as broad in scope as it is prolific. He has published upwards of 300 photobooks and has influenced his own and subsequent generations of photographers.

篠山紀信　Kishin Shinoyama
Photographer, b. 1940, 1960s.
Born in Tokyo. A graduate of the photography department of Nihon University College of Arts. While still a student he garnered much praise and received the first annual Japan Advertising Photographers' Association Award. After working for the advertising firm Light Publicity, he became an independent photographer in 1968. For many years he worked in the magazine world, photographing numerous covers. He came to popularity for his work with celebrities and several controversial photographs.

榎忠　Chū Enoki
Contemporary Artist, b. 1944, 1960s.
Born in Kagawa prefecture. From the latter half of the 1960s he was active in the Kansai region, mostly in performance art. In 1970 he assembled the troupe JAPAN.KOBE.ZERO. in Kobe, with more than 150 people participating in the group happening "Niji no kakumei" (Rainbow Revolution) in 1971. After the dissolution of the group, he held exhibitions not only in galleries and museums, but also at his home and its environs. His most notable exhibitions include: "Sono okoto, Enoki Chu" (That man, Enoki Chu), held at KPO Kirin Plaza in 2006; and "Shinohara Ushio to Enoki Chū" (Ushio Shinohara and Chū Enoki) at Toyota Municipal Museum of Art in 2007.

谷口吉生　Yoshio Taniguchi
Architect, b. 1937, 1970s.
Born in Tokyo. His father was the modernist architect Taniguchi Yoshirō. He has had few projects outside Japan, but garnered world attention for his sophisticated sense of proportion and refined Japanese aesthetic with the commission of the MoMA's new wing. In 2005, he was awarded Japan's Praemium Imperiale. His principal works include: Tokyo Sea Life Park (1989), Marugame Genichiro-Inokuma Museum of Contemporary Art (1991), and Tokyo National Museum (1999), among others.

藤森照信　Terunobu Fujimori
Architectural Historian, Architect, b. 1946, 1970s.
Born in Nagano Prefecture. Teaches at the Institute of Industrial Science at the University of Tokyo. His principal area of study is the history of Japanese modern architecture. In 1982, he published "Meiji no Tokyo Keikaku" (Tokyo Planning of the Meiji Period), which received the Mainichi Newspapers Culture Award. In 1974 he established the Tokyo Kenchiku Tantei-dan (Tokyo Architecture Detective Group), to exhume forgotten and buried examples of Western architecture in Japan. In 1986, with Genpei Akasegawa and Shinbō Minami, he formed the Rojō kansatu gakkai (Street Observation Assembly), which looked at less-prominent buildings in the city. In 1991, he started his first architectural project, Chino City Jinchō Moriya Archive. Other notable projects include Tanpopo House and Nirahouse. In 2006, he participated in the architecture exhibit at the Venice Biennale.

杉本博司　Hiroshi Sugimoto
Contemporary Artist, b. 1948, 1970s.
Born in Tokyo. In 1970, he moved to the United States, and started taking photographs in New York in 1974. "Theaters" and "Seascapes" were praised for their clear concept and excellent execution, and his work was acquired by numerous museums internationally. In 2001, he received the Hasselblad Foundation International Award. Recently, his activities have expanded to include writing and architecture. In 2008, his book of essays and photography "Utsutsu na zō" (Shinchōsha) was published and in the same year he established artablished a research facility for the use of new materials in architectural design. In 2009, his redesign of a building for Izu Photo Museum opened.

大竹伸朗　Shinro Ohtake
Painter and Contemporary Artist, b. 1955, 1980s.
Born in Tokyo. Upon his painting debut in the early 1980s, his work was celebrated for heralding a new style, and he has remained at the forefront of contemporary art ever since. His use of material is all-encompassing and his output prolific. His work covers a broad range of themes and media including: sculpture, photography, books, printed matter, and music. In 2006, his exhibition "Zenkei," at the Museum of Contemporary Art Tokyo, which has the largest exhibition wall space in Japan, included some 2,000 works.

宮島達男　Tatsuo Miyajima
Contemporary Artist, b. 1957, 1980s.
Born in Tokyo. He makes extensive use of numbers in digital displays within site-specific works. Since his participation in the 1988 Venice Biennale, he has participated in numerous international exhibitions. His work has been acquired as part of the permanent collections of London's Tate Gallery, Munich's Pinakothek der Moderne, and the Museum of Contemporary Art, Tokyo. He also has created several public art works.

しりあがり寿　Kotobuki Shiriagari
Manga Artist, b. 1958, 1980s.
Born in Shizuoka Prefecture. A former employee of Kirin Beer, in charge of advertising and product development. From 1985 he pursued a career as a manga artist on the side, and since 1994 he has worked exclusively in manga. In 2000, he received the 46th annual Bungei Shunjū Manga Award. In 2001, he was awarded the 5th annual Tezuka Osamu Culture Prize for Manga Excellence. He also has held several museum exhibitions of his illustrations.

大岩オスカール　Oscar Oiwa
Painter and Contemporary Artist, b. 1965, 1980s.
Born in San Paolo and raised in Brazil by Japanese parents. Since studying architecture at university, he has pursued his artistic activities. In 1991, in his late 20s, he moved to Tokyo. By the time he moved to New York in 2002, he had been active in Tokyo for eleven years. With a continually changing base, his art has developed a unique multi-cultural perspective. In 2008, a large-scale traveling exhibition of his work opened at the Museum of Contemporary Art Tokyo.

奈良美智　Yoshitomo Nara
Painter and Contemporary Artist, b. 1959, 1990s.
Born in Aomori Prefecture. He studied at the Staatliche Kunstakademie Düsseldorf, as well as with the German painter and sculptor A.R. Penck. Between 1994 and 2000, he worked in Cologne, after which he returned to Japan. He has garnered a

young fan base for his punk-themed work. He has had exhibitions in Japan, throughout Asia and in the west. His art also has been featured in several documentaries.

鴻池朋子　Tomoko Kōnoike
Contemporary Artist, b. 1960, 1990s.
Born in Akita Prefecture. After graduating from Tokyo University of the Arts, she worked for many years as a designer of toys and objects before dedicating herself to art in 1997. In 2005, she began the first in a series of four large-scale painting narratives. Her works incorporate flora and fauna motifs in large-scale works, garnering much praise for their intensity. Apart from solo exhibitions held within Japan, she also has participated in several exhibitions abroad. In 2009, she held a major solo exhibition at the Tokyo Opera City Gallery.

三沢厚彦　Atsuhiko Misawa
Sculptor, b. 1961, 1990s.
Born in Kyoto. From 2000, he has created wood sculptures of animals with a humorless expression and approachable disposition, giving them an eerie resonance. In 2001, he was awarded the 20th annual Hirakushi Denchū Prize. In 2005, he received the 15th annual Takashimaya Art Award.

内藤礼　Rei Naito
Contemporary Artist, b. 1961, 1990s.
Born in Hiroshima. In her 1991 exhibition, "Chijō ni hitotsu no basho wo" (One place above ground), she presented an installation that was praised for its spiritual qualities, quiet composure, and inner reflection, drawing the attention of many. The same work was exhibited at the 1997 Venice Biennale. Composed of beads, thread, glass balls, and organdy fabric, the work was hailed as a subtle yet powerful space.

ホンマタカシ　Takashi Homma
Photographer, b. 1962, 1990s.
Born in Tokyo. After abandoning his university studies, he worked at an advertising agency. From 1991 to 92, he lived in London and shot for the fashion and culture magazine "i-D." After returning to Japan, he worked in fields ranging from advertising to magazine work, and began his principal bodies of photographic work, dealing with waves, suburbia, and the children of Tokyo. He began to exhibit his work in the mid-90s. In 1999, he released *Tokyo Suburbia*, photographs of Tokyo suburban landscapes and the people who inhabit them. He received the 24th annual Kimura Ihei Award.

吉永マサユキ　Masayuki Yoshinaga
Photographer, b. 1964, 1990s.
Born in Osaka. After operating a nightclub, working at food stalls, and in shipping, he planned to become a child welfare worker, but instead became a photographer. He photographs subcultures such as *ko-gal* (garishly made-up girls), gangs, *yankii* (thugs), nightclub scenes, and ethnic minorities living in Japan. Notable publications include "Zoku" (Tribe) (Little More), focused on bōsōzoku (fig. 38), and his book of essays "Mōshiwake gozaimasen" (No excuse) (Shinchōsha). Recently, his work "Shinjuku ID" served as a mural on the temporary walls of a construction site at the south exit of Tokyo's Shinjuku station, Japan's busiest train station.

会田誠　Makoto Aida
Contemporary Artist, b. 1965, 1990s.
Born in Niigata Prefecture. He made his artistic debut at the Rentogen Arts Research Facility Fortunes. Apart from his powerful expression and command of artistic skill, he has incorporated sometimes controversial themes into his work, including war, cruelty, death, anime, Lolita complex, and scatology, garnering much attention as a highly provocative artist.

天明屋尚　Hisashi Tenmyouya
Painter, b. 1966, 1990s.
Born in Tokyo and currently resides in Saitama. After working as an art director at a record company he turned to painting, in particular traditional Japanese forms such as *musha-e* (portraits of warriors), while deconstructing and evolving those styles. He raised the flag for "Butō-ha" (the School of Fight). His representative work is a series of satiric woodblock prints depicting legendary warriors from Japan's history.

ヤノベケンジ　Kenji Yanobe
Contemporary Artist, b. 1965, 1990s.
Born in Osaka. He debuted as an artist in 1990. He created a machine for contemporary society to survive a future end of days in the abandoned grounds of the 1970 Osaka World Expo, where he played as a child. From 1997, he started the Atoms Project, in which he donned a protective suit and visited the Chernobyl site. Since 2000, "revival" is a constant theme of his work.

西尾康之　Yasuyuki Nishio
Contemporary Artist, b. 1967, 1990s.
Born in Tokyo. Since his time in art school he has developed his own unique sculpting techniques. Since graduation, he has held several solo exhibitions, maintaining a prolific output. In 1999, he received the Kirin Contemporary Award, a subsidy for individual artists. In 2000, he won the grand prize of the

Okamoto Tarō Contemporary Art Award. In 2002, he was awarded the Grand Prix at the first GEISAI art festival. Many of his works incorporate themes of destruction and corpse motifs.

中村哲也 Tetsuya Nakamura
Contemporary Artist, b. 1968, 1990s.
Born in Chiba. After graduating from art school in 1994, he started the "Replica" series of large-scale sculptures based on images of the world's fastest objects, as well as a series of intricately patterned motorcycles and automobiles using the techniques and tools of traditional Japanese handcrafts. He has held exhibitions at the Hermès Salon (2002), Suntory Museum (2002), and Yokohama Sogō Museum (2003).

山口晃 Yamaguchi Akira
Painter, b. 1969, 1990s.
Born in Tokyo. In 1997, he participated in the group exhibition "Kotatsu-ha," which raised his profile. He has subsequently gained recognition for his Yamoto-e and *ukiyo-e* illustrations, with their renderings of birds-eye views and warriors with a heightened sense of reality. In his principal works, buildings, wood constructions and the people of Edo-period Japan are re-imagined in a contemporary department store context.

須田悦弘 Yoshihiro Suda
Artist, b. 1969, 1990s.
Born in Yamanashi Prefecture. From 1994 to 1999 he shared a studio space with the artists Tetsuya Nakamura and Daisuke Nakayama. His delicate wooden flower sculptures are nearly indistinguishable from actual flora. He considers the sculpture itself to be an integral part of the space in which it is present, and is therefore only complete once the sculpture is installed. In 2006, a major exhibition of his work was held at Marugame Genichirō-Inokuma Museum of Contemporary Art, Kagawa, and the National Museum of Contemporary Art, Osaka.

町田久美 Kumi Machida
Painter, b. 1970, 1990s.
Born in Gunma. Her first paintings were colorful works in the Nihon-ga style, but since 1995 she has shifted toward extensive use of contour. In 2007, she was awarded the Sovereign Art Prize (Hong Kong). In 2008 a solo exhibition of her work was held at Kestnergesellschaft, Hannover.

風間サチコ Sachiko Kazama
Illustrator, b. 1972, 1990s.
Influenced by her father, the proprietor of an arts supply store, she became interested in *ukiyo-e* and woodblock prints. Addressing themes of poor urban planning, the economic crash of the 90s, and Japanese politics, she produces contemporary woodblock prints rich with satire and humor. In 1992, she was awarded the Parco GOMES Manga Prix. In 2006, she received the Award of Excellence from the Okamoto Tarou Memorial Museum.

田附勝 Masaru Tatsuki
Photographer, b. 1974, 1990s.
Born in Toyama Prefecture. After graduating from high school, he worked at a film company. During this time he came across a documentary photography book on cowboys, which inspired him to take up photography. In 1995, after working as a studio assistant, he became a freelance photographer. Focussing initially on portraiture, his work has appeared in magazines, on CD covers, and in advertising. He has since started photographing decorated trucks, publishing in 2008 a photobook of these works titled *Decotora* (Little More).

束芋 Tabaimo
Contemporary Artist, b. 1975, 1990.
Born in Hyōgo Prefecture. A student of the Kyoto University of Art and Design, her final graduation project won the 1999 Kirin Contemporary Award for Highest Excellence. She has rapidly become a star of the contemporary art world, participating in the Yokohama Triennale 2001, the 2002 Sao Paolo Biennale, and the 2006 Sydney Biennale. She also has held solo exhibitions at Tokyo Opera City, the Hara Museum, and the Fondation Cartier pour l'Art Contemporain in Paris.

ミヤケマイ Mai Miyake
Illustrator, date of birth undisclosed, 2000s.
Born in Kanagawa Prefecture. She made her debut as an artist in 2002, earning attention for her reinterpretation of Japanese sensibilities and aesthetics in a contemporary context. Her work is not limited to the field of painting. She held an exhibition titled "Ocha no jikan" (Japanese tea time) at Shibuya's Bunkamura Gallery, created an installation at the Ginza Hermes window display, has created original merchandise for Mori Arts Center's museum shop, as well as creating book illustrations, and designing kimono and yukata. In 2009, she studied at the University of Paris.

松井冬子　Fuyuko Matsui
Painter, b. 1974, 2000s.
Born in Shizuoka. In 2007, she became the first woman to receive a doctorate in Nihon-ga painting from Tokyo University of the Arts. In 2005, she held her first exhibition at Tokyo's Naruyama Gallery. Her works, which address deathly themes and include motifs such as anthropomorphic flowers and bodily organs, appear grotesque at first but are rendered in a delicately refined manner.

石上純也　Junya Ishigami
Architect, b. 1974, 2000s.
Born in Kanagawa prefecture. After graduating from Tokyo University of the Arts, he worked at the architectural firm of Kazuyo Sejima. In 2004, he established his own architectural office. At Art Basel's Art Unlimited in 2006, he exhibited a table with a thickness of just three millimeters, a forerunner to new materials that would be used in both architecture and art. In 2008, he designed the Japanese pavillion at the 11th Venice Architecture Biennale.

小瀬村真美　Mami Kosemura
Contemporary Artist, b. 1975, 2000s.
Born in Kanagawa Prefecture. In 2005, she completed her doctorate at Tokyo University of the Arts. In her "moving paintings" she re-edits and recomposes historical icons, of Western painting styles, Japanese paintings, pre-existing images through the use of digital imaging, photography, and video. Her video works are primarily shown as installations.

田中圭介　Keisuke Tanaka
Artist, b. 1976, 2000s
Born in Chiba. Studied sculpture at the Tokyo University of the Arts, concentrating principally on wood sculpture, which he considered "wood's corpse." His sculpture is at once a the wood as is while also taking the form of a landscape, evoking nature's mysticism. He has participated in numerous group shows and has held solo exhibitions in Tokyo.

冨谷悦子　Etsuko Fukaya
Contemporary Artist, b. 1981, 2000s.
Born in Aichi Prefecture. In 2006, while a graduate student, she held her debut exhibition at Yamamoto Gendai gallery, Tokyo. In 2009, she held her second exhibition. She makes detailed renderings with copperplate prints. She has participated in the group shows "Alllooksame? Tuttuguale? Art China Korea Japan" (Torino, 2006), "Young Artists" (Yokohama Museum of Art, 2007), and "Roppongi Crossing" (Mori Art Museum, 2007).

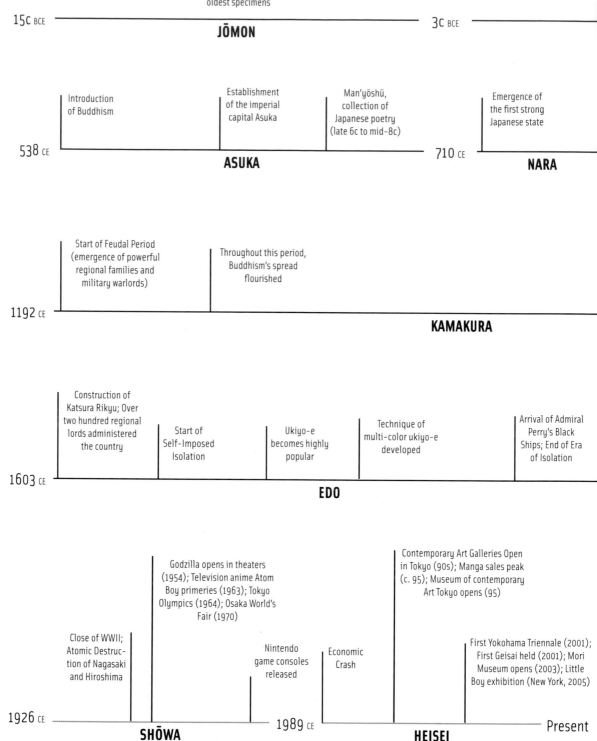

Earthenware of the Jōmon
period dates among the world's
oldest specimens

15c BCE ——————————————————— 3c BCE ———————

JŌMON

Introduction
of Buddhism

Establishment
of the imperial
capital Asuka

Man'yōshū,
collection of
Japanese poetry
(late 6c to mid-8c)

Emergence of
the first strong
Japanese state

538 CE

ASUKA

710 CE

NARA

Start of Feudal Period
(emergence of powerful
regional families and
military warlords)

Throughout this period,
Buddhism's spread
flourished

1192 CE

KAMAKURA

Construction of
Katsura Rikyu; Over
two hundred regional
lords administered
the country

Start of
Self-Imposed
Isolation

Ukiyo-e
becomes highly
popular

Technique of
multi-color ukiyo-e
developed

Arrival of Admiral
Perry's Black
Ships; End of Era
of Isolation

1603 CE

EDO

Godzilla opens in theaters
(1954); Television anime Atom
Boy primeries (1963); Tokyo
Olympics (1964); Osaka World's
Fair (1970)

Contemporary Art Galleries Open
in Tokyo (90s); Manga sales peak
(c. 95); Museum of contemporary
Art Tokyo opens (95)

Close of WWII;
Atomic Destruc-
tion of Nagasaki
and Hiroshima

Nintendo
game consoles
released

Economic
Crash

First Yokohama Triennale (2001);
First Geisai held (2001); Mori
Museum opens (2003); Little
Boy exhibition (New York, 2005)

1926 CE ————————————— 1989 CE ———————— Present

SHŌWA **HEISEI**

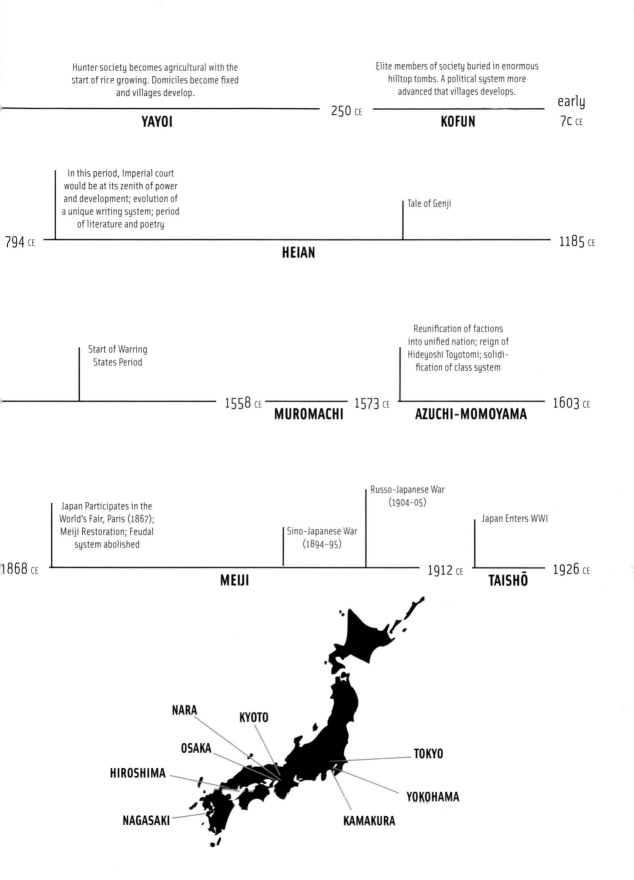

Hunter society becomes agricultural with the start of rice growing. Domiciles become fixed and villages develop.

YAYOI

250 CE

Elite members of society buried in enormous hilltop tombs. A political system more advanced that villages develops.

KOFUN

early 7c CE

794 CE

In this period, Imperial court would be at its zenith of power and development; evolution of a unique writing system; period of literature and poetry

Tale of Genji

HEIAN

1185 CE

Start of Warring States Period

1558 CE

MUROMACHI

1573 CE

Reunification of factions into unified nation; reign of Hideyoshi Toyotomi; solidification of class system

AZUCHI-MOMOYAMA

1603 CE

1868 CE

Japan Participates in the World's Fair, Paris (1867); Meiji Restoration; Feudal system abolished

Sino-Japanese War (1894–95)

Russo-Japanese War (1904–05)

Japan Enters WWI

MEIJI

1912 CE

TAISHŌ

1926 CE

NARA
KYOTO
OSAKA
HIROSHIMA
NAGASAKI
KAMAKURA
YOKOHAMA
TOKYO

First published in the United States in 2011 by Chronicle Books LLC.
First published in Japan in 2010 by Heibonsha.

Library of Congress Cataloging-in-Publication Data available.

ISBN: 978-0-8118-6957-7

Manufactured in China.

Book design and layout:
Goliga Books, Inc., Kazunari Hattori and Tomoko Yamashita
Original type graphics by Kazunari Hattori
Cover design: Emily Craig
Edition coordination by Rico Komanoya/ricorico

Front cover, Left: Tenmyouya Hisashi, *RX-78-2 Kabukimono 2005 Version*,
2005. Acrylic, gold leaf, wood. 200 × 200 cm. © Sotsu Sunrise © 2005
Tenmyouya Hisashi. Courtesy of Mizuma Art Gallery. Right: Kuniyoshi
Utagawa, *Honjō Shigenaga Parrying an Exploding Shell*, Late Edo period.
Woodblock print. Photograph: visipix.com

Title is a production of Goliga Books, Inc., Tokyo. Editorial and art direction
by Ivan Vartanian for Goliga Books, Inc.

www.goliga.com

10 9 8 7 6 5 4 3 2 1

Chronicle Books LLC
680 Second Street
San Francisco, CA 94107
www.chroniclebooks.com